DIGITAL QUICK GUIDE™

POSING TECHNIQUES
FOR DIGITAL PORTRAITS

A PHOTOGRAPHER'S GUIDE TO
MAKING EVERYONE LOOK THEIR VERY BEST!

Jeff Smith

AMHERST MEDIA, INC. ■ BUFFALO, NY

Published by:
Amherst Media, Inc.
P.O. Box 586
Buffalo, N.Y. 14226
Fax: 716-874-4508
www.AmherstMedia.com

Publisher: Craig Alesse
Senior Editor/Production Manager: Michelle Perkins
Assistant Editor: Barbara A. Lynch-Johnt

ISBN: 1-58428-155-3
Library of Congress Card Catalog Number: 2004113070

Printed in Korea.
10 9 8 7 6 5 4 3 2 1

TABLE OF CONTENTS

INTRODUCTION

The human form. It can be shaped and proportioned to be one of the most beautiful subjects on earth. At the same time, the body can be arranged in such a way that it makes even the most attractive person look almost disfigured.

Further complicating this arrangement of the human form are all the different shapes and sizes of people that we must work with. It is one thing to make a perfect model look good—but use the same kinds of poses on average people, and you will end up with a portrait that simply isn't flattering.

So, what is it that makes one arrangement of body parts look so graceful, while another arrangement looks so awkward? That is the subject of this book.

All you'll need to complete the following exercises are a digital camera and some willing subjects. It doesn't hurt if they also happen to be pretty patient people—you may want to take quite a few images at a time to try out different variations.

As you learn to make people look their best, you'll find that you like your images more—and that people are more willing to pose for you (since they know you'll flatter them!).

Good luck!

1. GETTING STARTED

Before we dive into where to place people's hands and how to turn their heads, there are a few basic issues we need to consider. How do you get ideas for posing? Does it make a difference if your subject is a man or a woman? How do you get people to pose the way you want them to? These are all good questions. Here are the answers.

■ POSING IDEAS

It can be intimidating to stand face-to-face with a subject and try to think of how to pose them. In fact, most people don't pose their people pictures at all—they just take a picture of the subject however they happen to be positioned at the moment. That's a big reason why most snapshots look unprofessional and unpolished. If you have a few ideas in mind, though, you can make the process easy.

One way to get ideas is to watch people—see how they normally stand and sit. Watch what they do with their arms. Be especially aware when you see someone and think, "Hey, they look really good like that!" Make a mental note and plan to use the same pose later for a portrait.

> Another way to get started thinking about posing is to look at magazines.

Another way to get started thinking about posing is to look at magazines. Sometimes, the posing in these will be too formal for everyday images, but you can also find more casual poses that will work very well.

■ GIRLY GIRLS AND MANLY MEN

Some people (even some professional photographers) seem to think that men have to look tough and women have to look soft and feminine. It's just not true. Select a pose that works for your subject and suits their personality. Today's women want to look like women, of course, but they don't want to look like docile creatures without a thought in their head. Guys have changed, too, from the days of the stiff "rugged guy" portrait. We don't kill our own prey, we shower regularly (well, until the whole "grunge" thing), we help raise our children, and we are allowed to be much less rigid and unemotional. It's alright to have Dad lean forward or

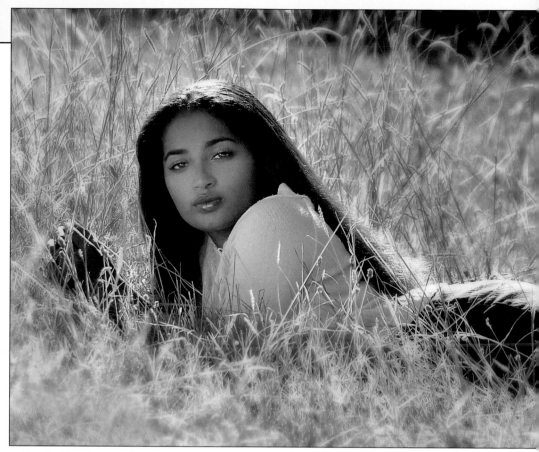
Taking the time to properly pose your subjects gives portraits a polished, professional look.

recline back slightly. He can even smile a little in a family portrait, so he actually looks like he is enjoying himself.

■ SHOW, DON'T TELL

One of the best ways to pose your subjects is by posing yourself first. If you can't demonstrate the pose yourself—if it feels awkward or uncomfortable—you can bet your subject will have trouble with it, too. If a pose isn't comfortable, you can also bet you'll see it on your subject's face. It's hard to get images with a good expression if your subject has leg cramps or feels silly.

In addition to weeding out bad poses, showing a pose is also the quickest way to communicate what you want. It's much easier than having to say, "Okay, put your left ankle on your right knee, move your right hand onto the arm of the chair . . ."

7

2. COMMON MISTAKES: THE FACE, PART 1

We will begin our look at posing in a backwards fashion, by looking at what *not* to do—or catching the obvious mistakes made by most photographers. If you make sure that a pose doesn't contain any of these problems, you can be pretty sure the pose will be good.

■ **MISTAKE: TURNING THE SUBJECT AWAY FROM THE LIGHT**
Whether the light in your image comes from a flash, the sun, or a window, the subject should be turned mostly toward the light source. This doesn't mean they have to stare at it, but they should be facing in that general direction. The reason is simple: if the face is turned away from the light, the shadow on the side of the nose will increase, making the nose appear larger. When you turn the front of the face toward the main light source, you light the face without producing unflattering shadows.

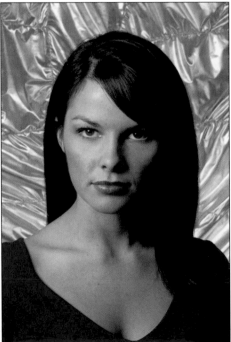

◀ GOOD!
With the subject's face turned toward the light, the shadows are flattering.

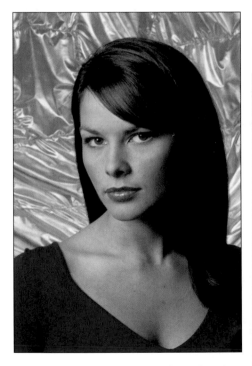

NOT SO GOOD! ▶
With the subject's face turned away
from the light, the shadows are unattractive.

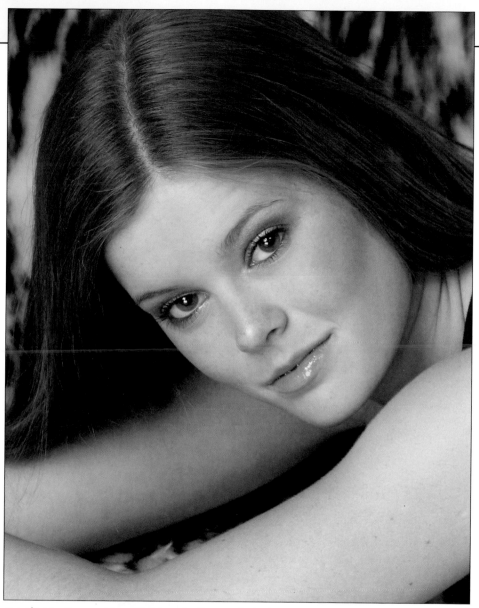

Catchlights, tiny sparkles of light, make the eyes look alive.

■ MISTAKE: NO CATCHLIGHTS

Catchlights are tiny, bright reflections on the colored part of the eye. If these aren't visible, the eyes won't look sparkly and alive. Check each shot before you click the shutter; if you don't see catchlights, reposition the subject's head (raising or lowering the chin, or turning the face more toward the main source of light in the image).

3. COMMON MISTAKES: THE FACE, PART 2

■ MISTAKE: GETTING THE WRONG EXPRESSION

An especially sweet smile, silly look, or intense glare can be the most memorable thing about a shot. So how do you get the expression you want? The first thing to keep in mind is that people will mirror the expression that you, the photographer, have on your face (when you smile at a person, they smile; when you frown at a person, they frown). You should also watch the way you speak. When you want the subject to smile, speak with energy and excitement in your voice. When you want a softer expression, speak in subdued tones.

SMILING ▶
Smiles are contagious. If you want your subject to smile, put a smile on your own face.

◀ SERIOUS
When you, as the photographer, have a serious look on your face, your subject will too.

■ MISTAKE: NOT TILTING THE HEAD

People rarely sit or stand with their head straight up. For a natural look, therefore, your subject's head should be slightly tilted toward one shoulder or the other—whichever direction looks most natural. Don't let them tilt their head too far, though; it can make them look tense or nervous.

When photographing a woman with long hair, I look at her hair to decide the direction the head will be tilted and the direction in which the body will be placed. Long hair is beautiful, and it looks best when it can drape freely. A woman's hair is usually thicker on one side of her head than the other. Tilting her head toward the fuller side of the hair will accentuate its beauty.

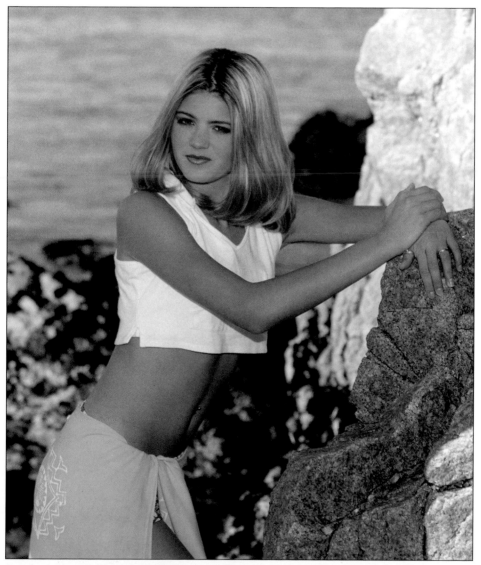

People rarely stand or sit with their heads straight up, so tilt the head for a more natural look.

4. COMMON MISTAKES: THE BODY, PART 1

Now, let's move on to some concerns that are related to the posing of the body. Avoid these problems, and you'll be well on your way to creating a well-posed image. Even if you only plan to photograph the subject's face, these tips will help you create a more flattering base for the portrait, with shoulders that look their most attractive.

■ THE WAIST AND HIPS

The widest view of any person—even a trim one—is when he or she is squared off to the camera. By turning the shoulders, waist, and hips to a side view, preferably toward the shadow side of the image, you create the thinnest view of the body—and don't we all want to look as thin as possible?

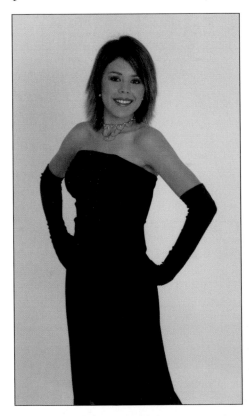

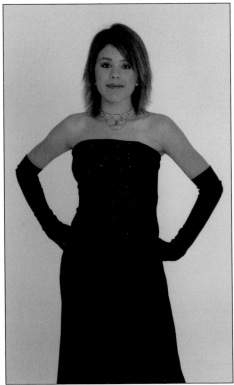

◄ GOOD!
With the subject's body turned, her waist looks slim.

NOT SO GOOD! ►
With the subject facing straight into the camera, she looks wider than she is.

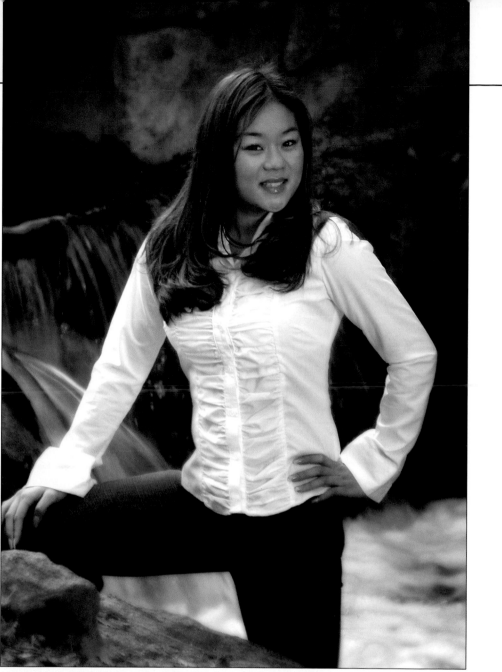

Keeping the arms away from the sides of the body slims the waist.

■ THE ARMS

When the arms are allowed to hang down to the sides of the subject, the body isn't defined. It is one mass—and that makes the body look a lot wider than it actually is. When the elbows are away from the body, the waistline is defined and appears smaller.

5. COMMON MISTAKES: THE BODY, PART 2

■ THE SPINE AND SHOULDERS

When you see a portrait of a person in which their shoulders are running perfectly horizontal through the frame, or in which the spine (if you can see it) is running perfectly vertical in the frame, the person in the portrait appears stiff. Visually, you are telling everyone who sees this portrait that your subject is uptight and very rigid. By posing the person reclining slightly backward or leaning slightly forward, the shoulders and spine go diagonally through the frame and you achieve a more relaxed appearance. The portrait will have a professional look and it will be more visually appealing. It will also create a more flattering representation of the subject's personality.

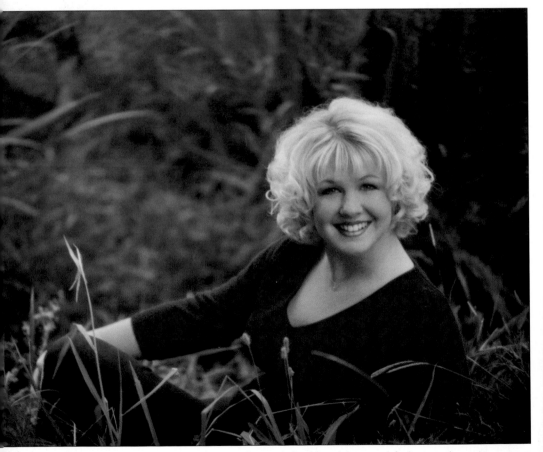

Adding a slight tilt in the subject's spine and shoulders (above and facing page) creates a more relaxed look.

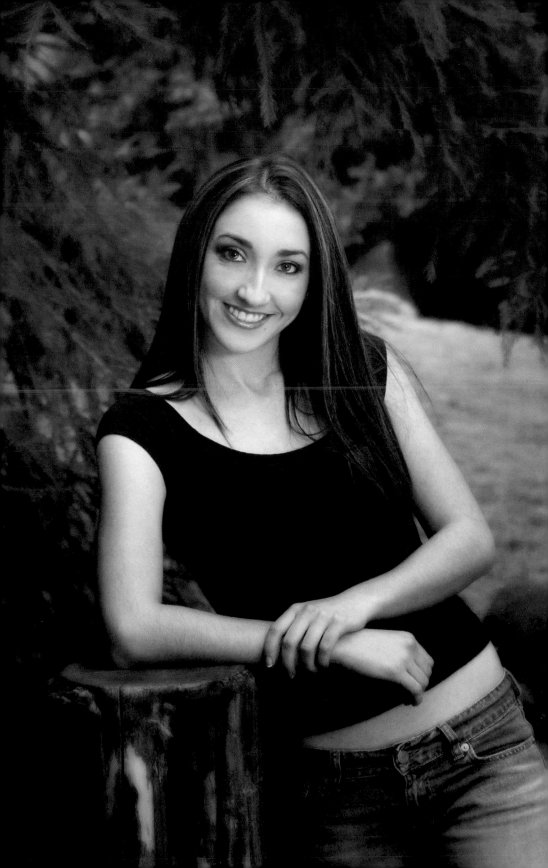

6. THE PURPOSE OF THE PORTRAIT

Now that we've looked at the most basic qualities of a well-posed portrait, we can move on to the finer details—the finishing touches that will make a portrait really shine.

The first thing to do when creating a portrait is to ask yourself why you're taking it and what you or the subject plan to do with it. Sometimes the purpose is clear. At a family reunion, you'll want photos that docu-

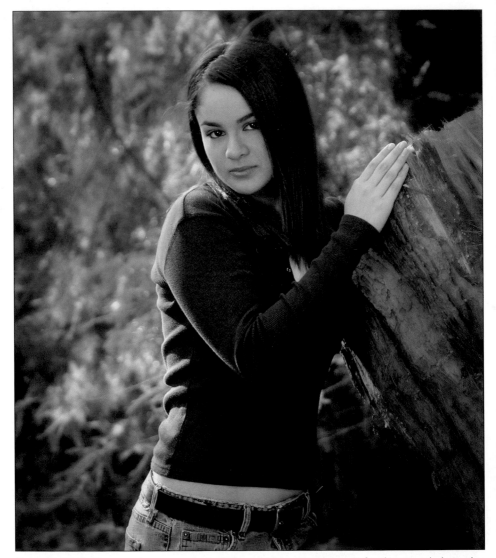

For some portraits, casual poses are best. This would be a great portrait for the young lady to give her parents.

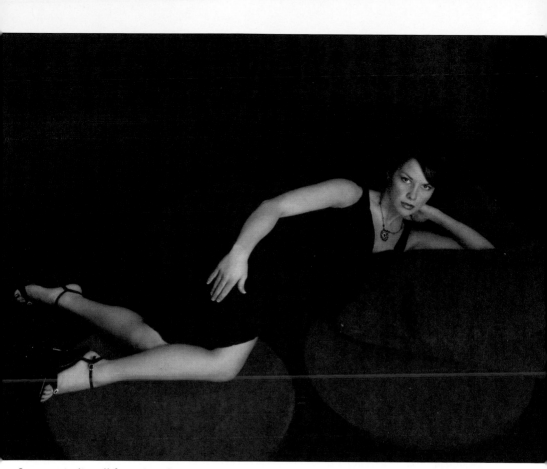

Some portraits call for a more intense expression and posing that is designed to make the subject look as attractive as possible. These portraits make good gifts for the subject's significant other.

ment the various families, the growing children, etc. You'll probably share the images with your relatives and maybe display them in your home. At a bachelor party, the types of images you'd take, who they would be shared with, and how they would be shared could be quite different.

Sometimes you may have to talk with your subject to determine what he or she wants. Imagine, for example, that your friend asks you to take her picture. In order to ensure you'll get just the shot she wants, you'll need to ask some questions. Does she want a traditional, smiling picture to send to her mom? Does she want an official-looking shot to promote her career? Does she want an alluring shot for her husband? Obviously, her answers to these questions would determine the type of pose that would be appropriate.

Once you know the purpose of the portrait, you can decide if the posing should be traditional, casual, or glamorous.

7. POSING STYLES: TRADITIONAL

Traditional posing is used for portraits for business, yearbooks, people of power, and people of distinction. This style of posing reflects power, and to some degree wealth, respect, and a classic elegance. Whether these portraits are taken in a head-and-shoulders or full-length style, the posing is more linear, with only slight changes in the angles of the body.

Whether the subject is a judge, a businessperson, or a priest, the posing needs to be subtle. Most of the time, these portraits are taken in more formal clothing. As such, the subject may feel more comfortable in a standing position. Still, the subject's arms shouldn't rest on the side of the body. An elbow can rest on a chair, or the hands can be put into the pockets—but not so deep as to have the arms against the side of the body.

The expression used in this type of posing should be subtle to serious. Big, goofy smiles are definitely not appropriate—but at the same time, serious expressions need to be relaxed. Most people taking traditional portraits aren't comfortable doing so, and therefore have a tendency to scowl—and this needs to be avoided.

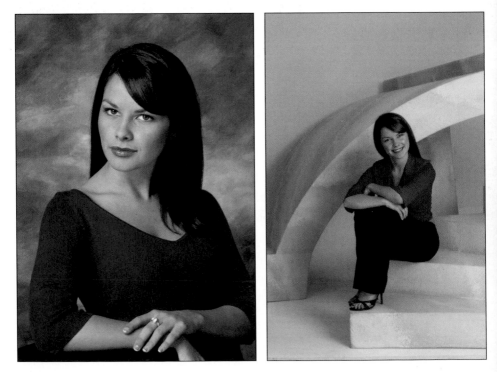

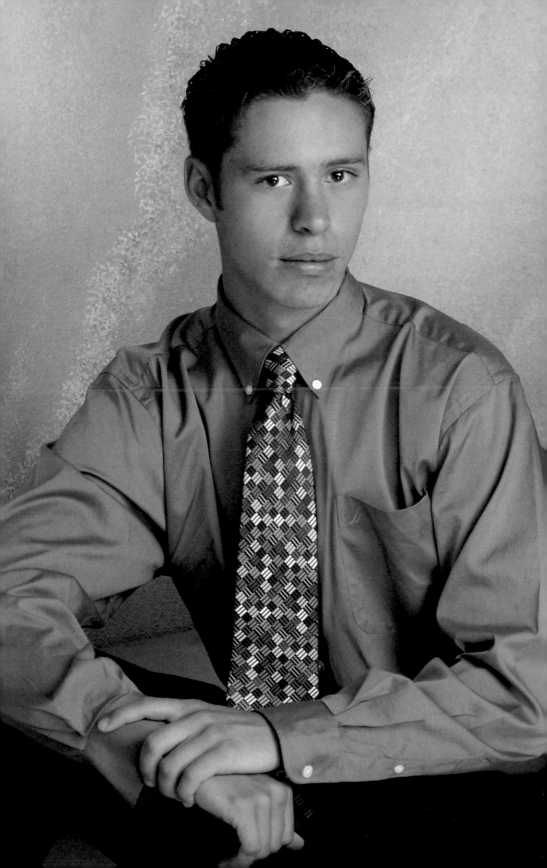

8. POSING STYLES: CASUAL

Casual posing is a style of posing in which the body is basically positioned as it would be when we are relaxing.

Observe people as they are watching TV, talking on the phone, or on a picnic, and you will see the most natural and best casual poses for your subjects. Casual poses are often used when the portrait is to be shared with family and friends.

Casual poses are resting poses. The arms rest on the legs, the chin rests on the hands. The back is posed at more of an angle. Subjects may be seated, leaning casually, or even laying on the ground. The purpose is to capture people as they really are.

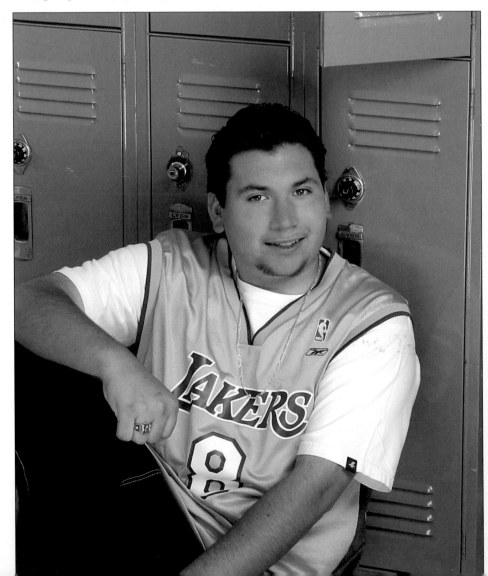

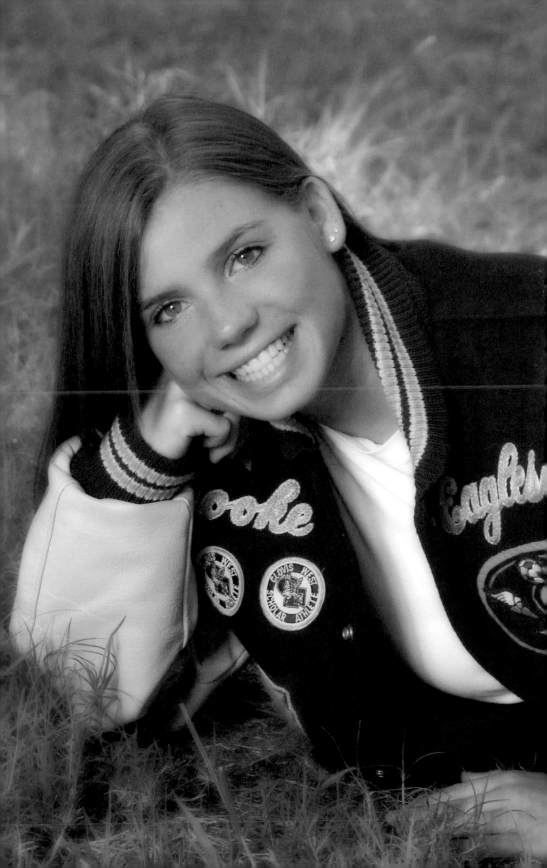

9. POSING STYLES: GLAMOROUS

Glamourous posing is sensual or sexy—it makes the subject look as appealing and attractive as possible. This doesn't mean the subject has to be provocatively dressed; you can pose a fully clothed human being in certain ways and make them look extremely glamourous and appealing. If you finish the pose with the right expression, often with the lips slightly parted, you will have made the subject's romantic interest very happy.

An excellent source of glamourous posing is found in catalogs such as those published by Victoria's Secret or Frederick's of Hollywood. The photographers who create these images are masters of making the human form look good to the opposite sex. Your subject will probably just have more clothing on.

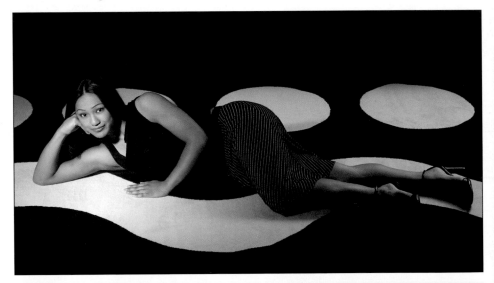

A GRAY AREA

When it comes to styles of posing, the lines are pretty gray. For example, many of my traditional poses are much more glamourous in their look than what the average photographer would consider traditional. This is because, as human beings, I think we all want to appear attractive. People who say they don't care how they look are the same people who say they don't care about money—and I think that people who would say things like that would lie about other things, too!

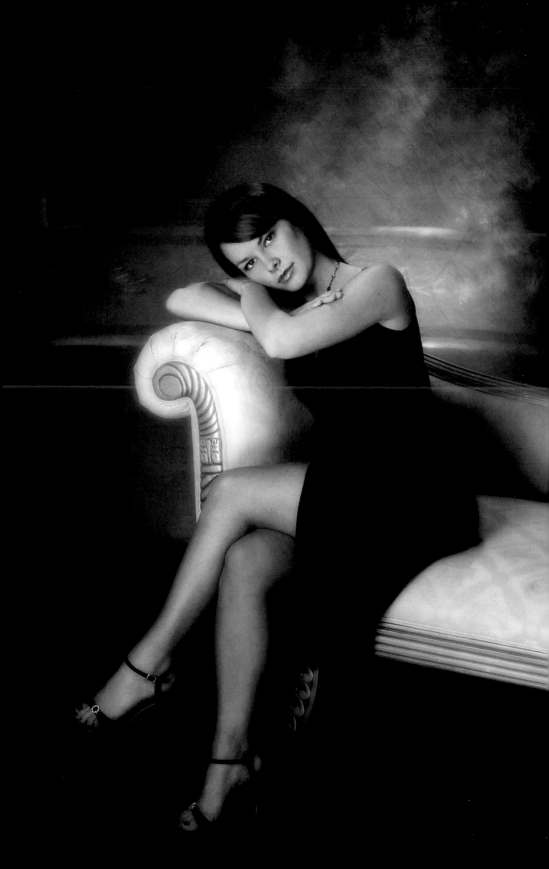

10. POSING STYLES: UNUSUAL POSES

Many photographers are afraid to pose their subjects in a way that may seem unusual—but sometimes it works out well. In the image below of a teenager and her mom, I noticed that the two seemed very close and had a lot of fun together. To show this relationship, I placed Mom in the grass and had her daughter sit on Mom's bottom leaning forward to rest

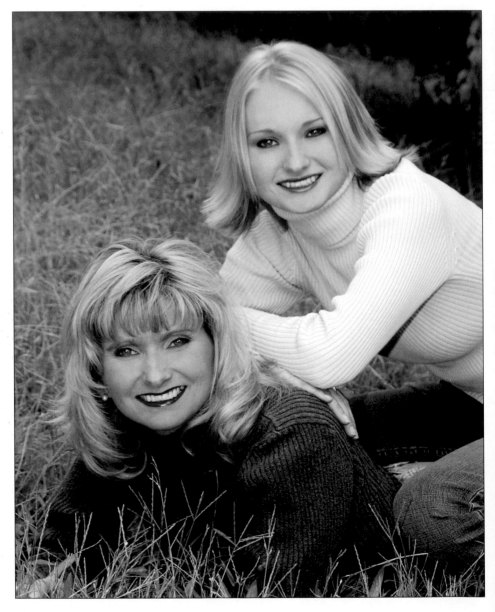

Use your imagination! Some of the best images arise from ideas that may at first seem unusual.

on her shoulders. I will be the first to tell you that when I asked the mother to lay down on her stomach, I received a puzzled look. However, most subjects will do what you ask if they believe in you and trust that the pose will be flattering. In this case, they loved it and used their portrait for Christmas gifts for the entire family. It captured something I saw between them and made them both look terrific.

11. PORTRAIT LENGTH

There are three basic types of portraits, and these are determined by the amount of the subject that is showing in the frame. Your subject, his or her clothing, the location, and even the purpose of the portrait may influence your decision as to which option is best.

■ HEAD AND SHOULDERS
Head-and-shoulders portraits show the subject's face and body down to a point no lower than the chest. This is good for any body type and almost any type of portrait.

■ THREE-QUARTER LENGTH
Three-quarter length portraits show the subject's face and their body down to a point no lower than the mid-thigh. This pose is good for subjects with average builds and works well for casual portraits.

■ FULL LENGTH
Full-length portraits show the subject from head to toe. This is flattering for thin subjects but should be avoided if weight is at all an issue.

Head-and-shoulders portraits.

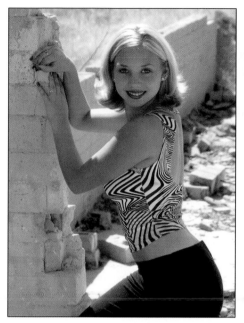
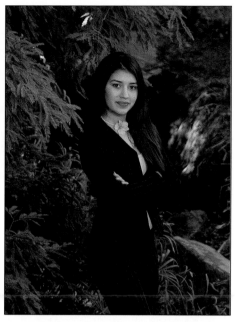

Three-quarter length portraits.

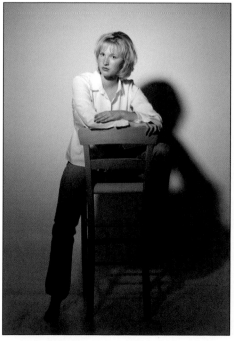
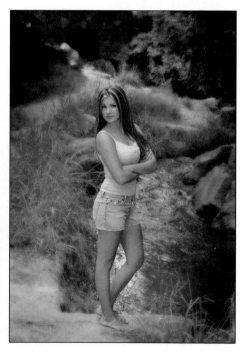

Full length portraits.

12. MATCHING THE POSE TO THE CLOTHES

The clothing that your subject is wearing will usually help you determine what type of pose will work best. For example, if you were photographing a woman in an evening gown at a cocktail party, you would probably select either a classic or glamorous pose. For a boy coming home from his first little-league game, a more casual pose would be most appropriate.

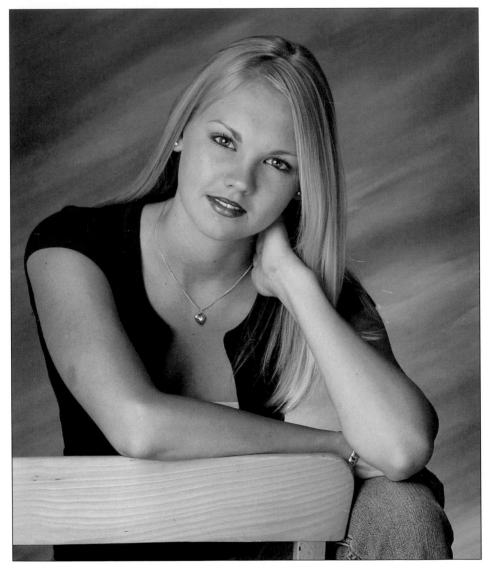

Casual clothes, like jeans and t-shirts, call for casual poses.

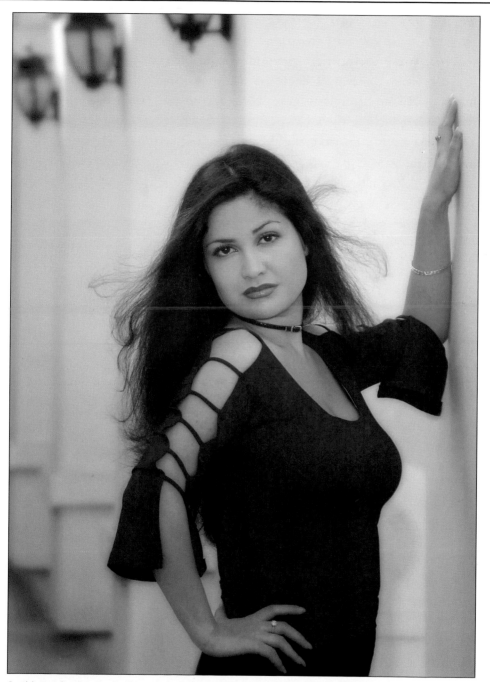

In this outdoor portrait, the mood of the scene is elegant. The clothing she is wearing and her pose both match this feeling and produce a striking portrait.

13. FURTHER CLOTHING CHOICES

When taking casual portraits, you may not have much control over what the subject is wearing—but you can still make decisions that will help make the portrait as good as possible. For example, if you see that a subject is wearing a sleeveless top that doesn't flatter her arms, you might ask if she brought a jacket with her, or you could make a portrait that doesn't include the area you think she won't want to see. Of course, any suggestions you make should be worded tactfully. No one wants to hear, "Your arms look really fat in that outfit, so let's try something else." Instead, you could say, "I noticed you have a nice sweater that matches your outfit—let's try using that in a few shots."

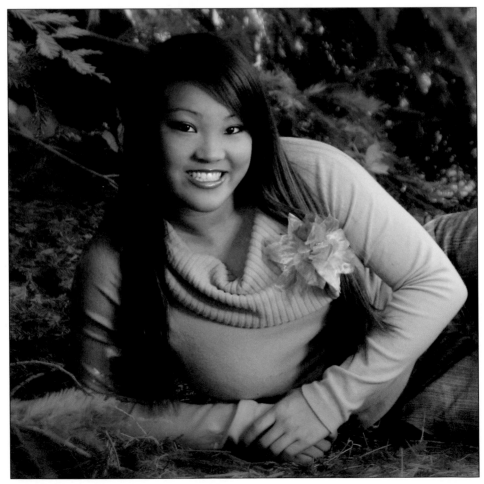

Long sleeves are flattering for any type of figure.

CLOTHING TIPS

Wear Long Sleeves. Many people don't like the look of their upper arms. Long sleeves cover this area and create a more flattering look. Even trim subjects often look best in long sleeves.

Choose Dark Clothing. If your subject might be at all concerned about his or her weight, dark clothes are a good choice. Pairing a dark outfit with a dark background is particularly slimming.

Choose Solid Colors. Prints and logos can be very distracting in a portrait. To keep the viewer's attention on your subject, suggest solid colors instead. Neutral tones often work well—especially for outdoor portraits where they coordinate nicely with the backgrounds.

Shoes. Shoes can be distracting in portraits—especially if they don't match the outfit, are very light colored (such as white sneakers), or are in poor condition. If this is the case in your image, either frame the image so the shoes don't show or ask the subject to go barefoot.

Jewelry. In your images, you want the viewer to focus on the subject. Jewelry can often distract from this, so you may want to ask the subject to remove any jewelry that doesn't enhance the image.

Too-Tight or Too-Loose Clothing. Pants or jeans that are too tight around the waist are a problem. Unless the subject is in great shape, the waistband will cut in and create a roll when he or she is seated. Tight clothing also adds weight to subjects who are heavier. Loose clothing, on the other hand, makes thin subjects look heavier—especially if it is loose around the waist or hips.

Undergarments. Keep in mind that a woman's undergarments need to coordinate with her outfit to create a polished look. Strapless tops call for strapless bras, and sheer fabrics should be worn with flesh-colored undergarments that don't show through. For women, stockings make the legs look more tanned and toned. If any of these problems appear, a portrait that does not include the trouble spots will be most flattering.

For some reason, many guys seem to wear white socks even with dark pants and shoes. This is very distracting in a portrait, so don't show this area if you see white socks peeking out!

14. COORDINATE WITH THE BACKGROUND

Just as the pose should match the style of clothing the subject is wearing, both the clothing and the pose should coordinate with the background that appears in the portrait. If the subject is wearing a t-shirt and shorts, photographing him or her in a formal ballroom will create an image that doesn't make much sense. If the subject is a little girl in a fancy dress, photographing her in a cornfield probably won't be the best choice.

Finding a good background doesn't require traveling to the four corners of the earth—you can probably find a good range of backgrounds around your house. A pretty staircase, well-maintained flower garden, or window with elegant curtains can work well for more formal portraits. A playroom, yard, or living room can be the perfect setting for your casual portraits. Even a nicely painted wall will work for many images.

It also helps if the colors in the background coordinate well with the colors in the clothing. Dark clothing looks good when paired with dark backgrounds; light clothing works well with light backgrounds.

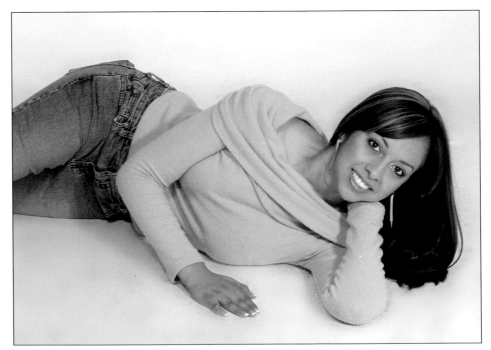

Lighter-colored clothes work well with light backgrounds (above); darker ones work well with dark backgrounds (facing page).

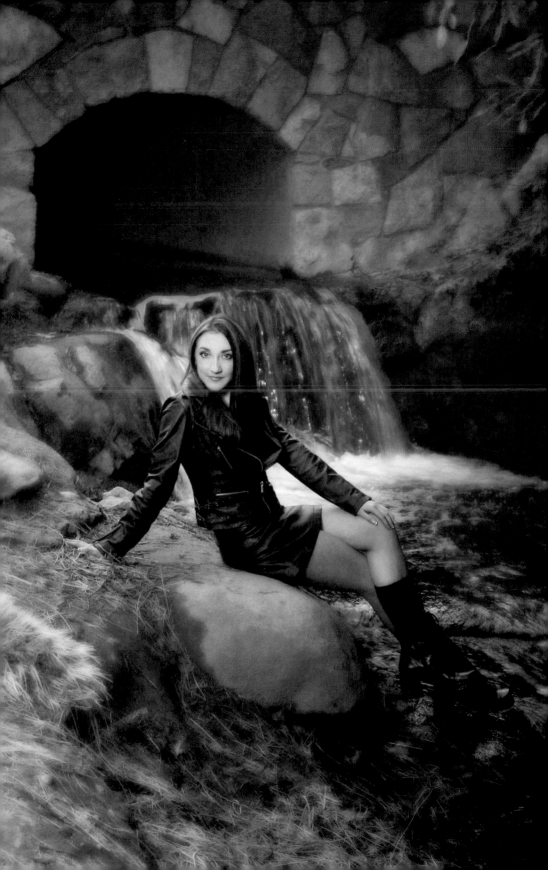

15. FACE POSITION

The subject's face can be positioned in three ways. Which one you choose will depend on your subject and the way you want your final image to look.

■ STRAIGHT ON

The first position is with the subject facing straight into the camera. In this pose, both ears are visible. This creates the widest possible view of your subject's face, so it's best used when photographing subjects whose faces are narrow.

■ AT AN ANGLE

Most faces look best when they are photographed at an angle to the camera. In this pose, the subject's face is turned so that the far ear just disappears. This is the face position you see in the majority of professional portraits.

■ PROFILE

If you continue to turn the subject's head away from the camera until the far eye disappears, you can create a profile—a flattering, classic pose.

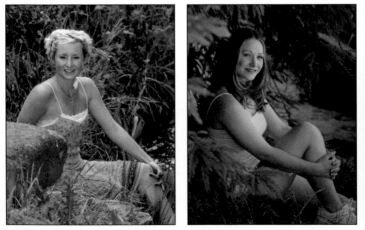

Portraits can show the subject's face straight-on (above, left), at an angle (above, right), or in a profile (facing page).

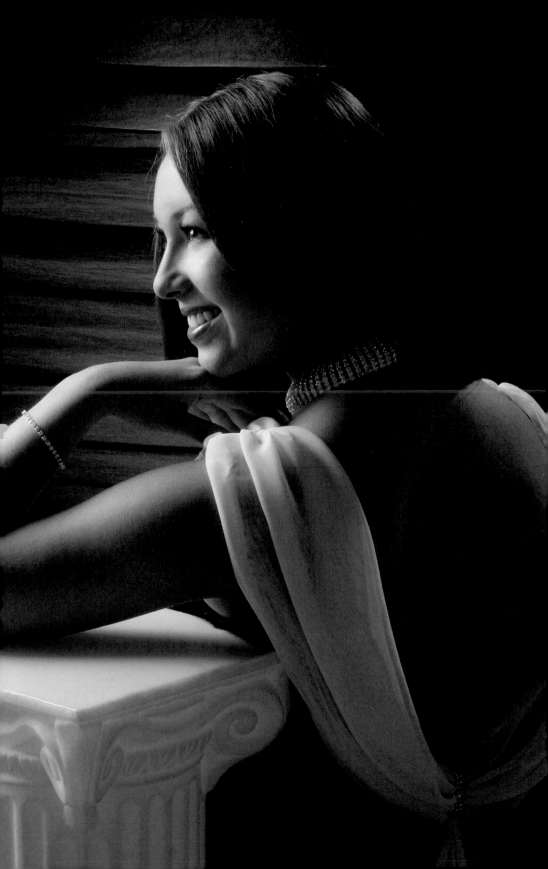

16. EYE POSITION

Most photographers don't really think about posing the eyes. They look at the face as a whole, but it is each part as well as *the sum* of the parts that make a good pose.

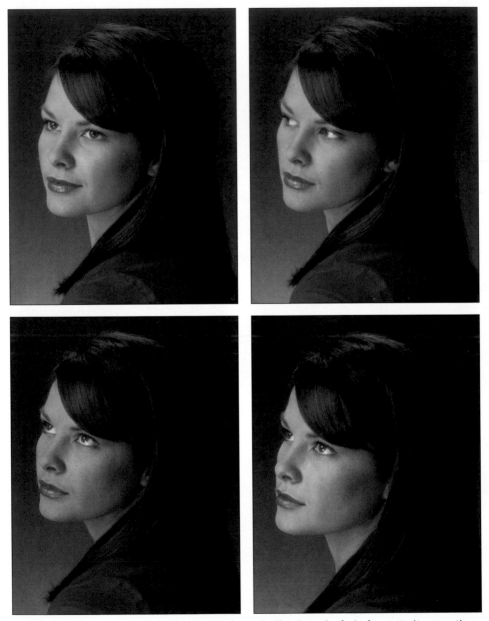

Changing the direction of the subject's gaze dramatically alters the feel of a portrait—sometimes not in flattering ways.

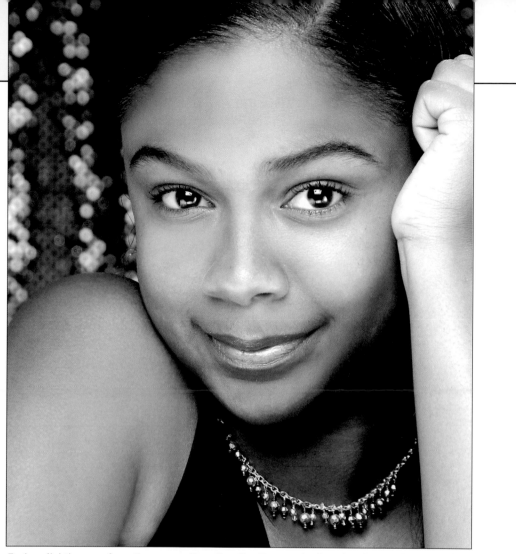

Facing slightly away from the camera then directing the gaze back makes the eyes look bigger.

There are two ways to control the position of the eyes in a portrait. First, you can change the pose by turning the subject's face. Second, you can have the subject change the direction of their eyes to look higher, lower, or to one side of the camera.

Typically, the center of the eye is positioned toward the corner of the eye opening. This enlarges the appearance of the eye and gives the eye more impact. This is achieved by turning the face slightly away from the camera, then bringing the subject's gaze back to the lens. This works well for all shapes of eyes, except for people with bulging eyes. When this is done on bulging eyes, too much of the white will show. This will draw attention to the problem.

17. EYE CONTACT

The point at which you ask the subject to focus their gaze in respect to the position of the camera's lens also, in essence, poses the eye. First and foremost, the subject should always be looking at some*one*, not some-*thing*. To do this, I put my face where I want their eyes to be. There is a certain spark that the eyes have when they look into someone else's eyes that they don't have when they are looking at a spot on the wall or a camera lens.

Usually, I position my face directly over the camera and have the subject look at me. When the eyes of the subject look into the lens (or very close to it), the subject seems to make eye contact with the viewer.

I find that most people prefer the intimate feeling of eye contact as opposed to the more reflective portraits where the eyes look off-camera—but you and your subjects may like a different look. If so, read on.

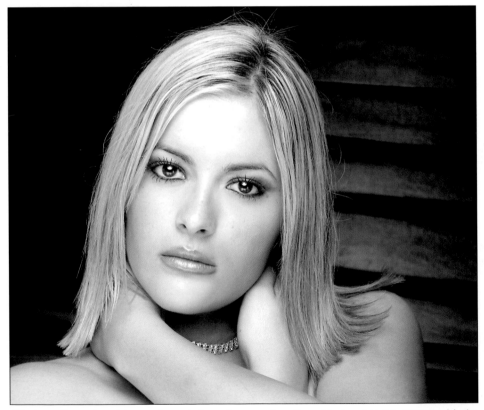

Whatever the posing style, most people favor images where the subject makes eye contact with the camera.

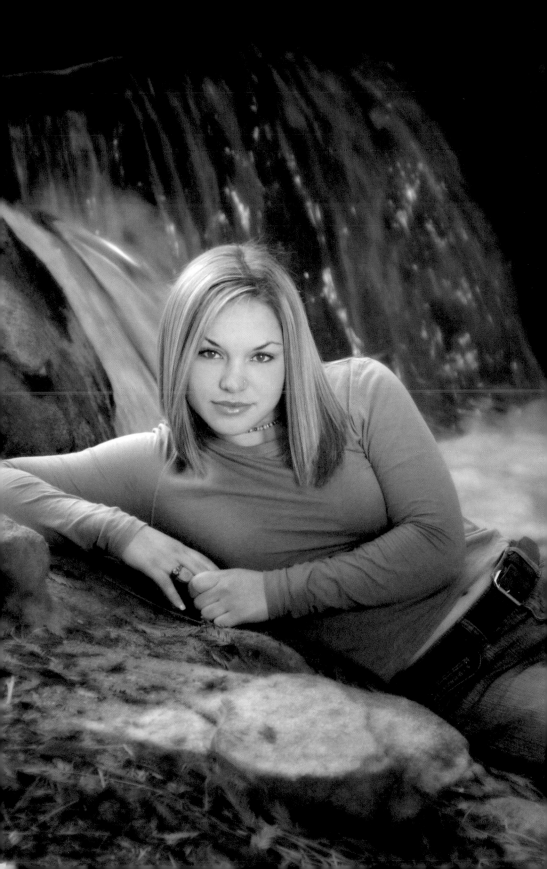

18. REFLECTIVE POSES

In reflective poses, the eyes look away from the camera. This works well when you want to tell a story. Think of a bride gazing out a window as if waiting for her groom, a high-school senior looking over the top of a book and off into the distance as she thinks of the future, new parents looking lovingly down at their baby, etc.

If the eyes are to look away from the camera, there are a few rules that need to be followed. They are really simple rules but ones that I see broken often.

First of all, the eyes should follow the same line as that of the nose. It looks ridiculous to have the eyes looking in a different direction than the nose is pointing.

As you turn the face away from the camera, there comes a point where the bridge of the nose starts to obscure the eye farthest from the camera. For the most professional-looking results, you should either have the subject go into a complete profile (see page 34) and show only one eye or turn their face toward the camera a little bit to provide a clear view of both eyes.

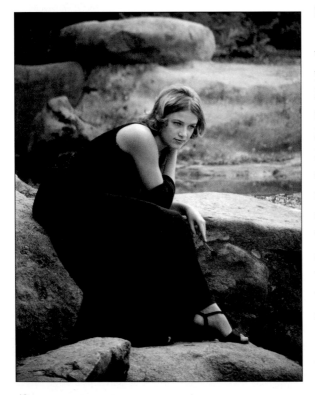

On page 8, you'll recall we discussed the fact that your subject should have his or her face turned toward the main source of light for the photograph. If you turn the subject for a more reflective pose, this means that you will also need to change the position of the light or the subject's position in relation to the light in order to maintain the desired angle.

When the subject looks away from the camera, the subject seems more reflective.

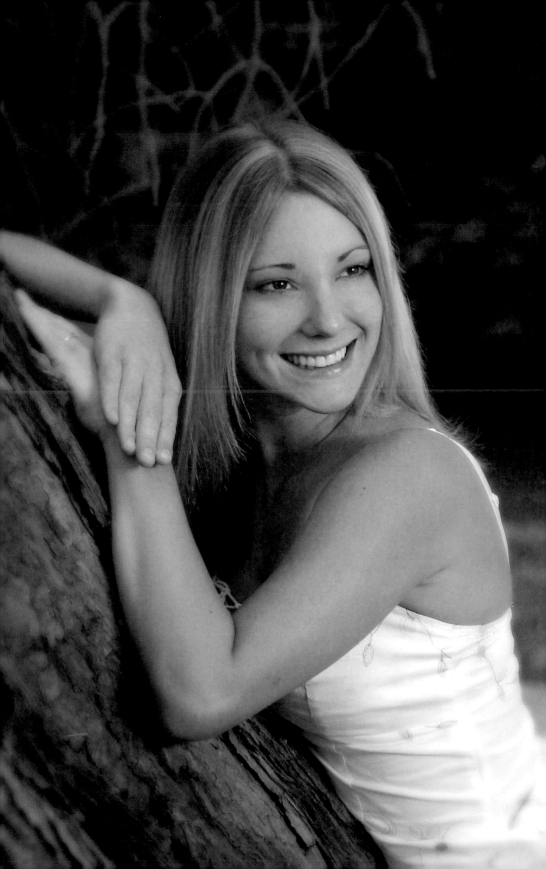

19. SQUINTING

■ BIG SMILES

When people smile, you can see it in their eyes. With big smiles, however, your subject may actually look as though they are squinting. If you observe this, you can rectify the problem by choosing a closed-lip smile instead of a big grin. Alternately, you might opt simply to create non-smiling portraits—which many people find more appealing and flattering anyway.

■ BRIGHT SUNLIGHT

As was noted on page 8, your subject should be turned toward the main source of light in your image. Outdoors, this may mean having the subject face the sun—and that can lead to serious squinting. To avoid this, look for shaded areas (under a tree or the overhang of a porch). Since the lighting will be more subdued, the subject should be able maintain a more pleasing expression.

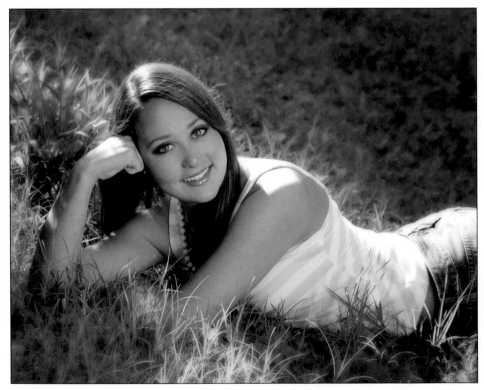

Working in a shaded area reduces squinting when the sun is bright.

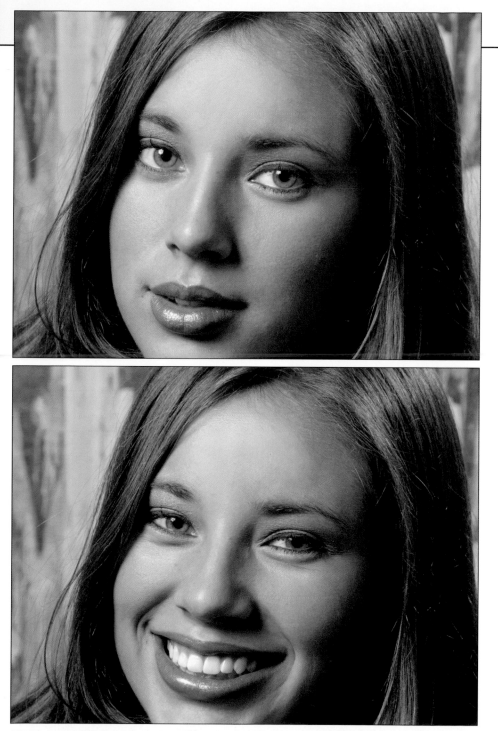

Watch your subject's eyes when you have them smile. Some people squint significantly when they have a big smile. If that's the case, choose a more moderate grin or even a serious expression.

20. EXPRESSION

The best expression for a portrait depends on the age of the subject and the purpose of the portrait.

■ AGE OF THE SUBJECT

For babies and small children, people almost always prefer laughing smiles (although sleeping babies are also big favorites).

For school-age children, smiles will still work, but more serious expressions are also very nice.

For adults, more subtle expressions are desirable. While squinty eyes are cute on a baby, not many adults want to see themselves with

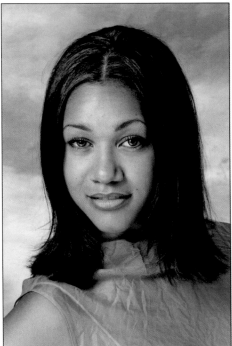

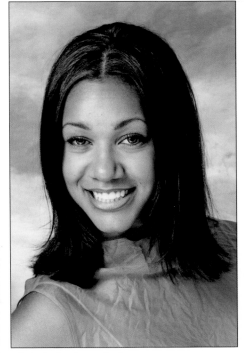

Even a small change in expression can change the whole look of a portrait.

virtually no eyes, huge chubby cheeks, and every tooth in their mouth visible. Large smiles are not only unflattering to adults for these reasons but also because the expression tends to bring out every line and wrinkle on a person's face. Adults are always self-conscious about crow's feet, smile lines, and bags under the eyes—all of which are made much more noticeable by huge smiles. The only adults that can really pull off a big smile are cheerleader types or the few people who have that perfect "Colgate smile."

■ PURPOSE OF THE PORTRAIT

If the image you are creating is intended for the subject's family or friends, a soft smile will work well. If it is intended for the subject's spouse or romantic interest, a more intense expression is probably called for. If you are creating an image that the subject wants to use to promote her new computer consulting business, a more serious and professional look would be best for inspiring trust among her prospective clients. If, on the other hand, your friend was starting a business as a performer at children's birthday parties, the expression could be much more happy—maybe even silly!

TIPS FOR FLATTERING SMILES

Timing. When you want a smiling expression, the timing is important. When most adults first start to smile, the expression is an enormous, laughing smile. If you snap the picture at this point, your subject will have big cheeks and squinty eyes—and they probably won't love the portrait. A moment or two later, the smile starts to relax. This is the time to take your picture, since it's the smiling expression that most adults prefer.

Skip the "Cheese." We are all taught to have our subjects say "Cheese!" (or "Fuzzy pickle!" or even just "Smile!") to get the expression we are looking for. If you've tried this, you've probably noticed it doesn't work. Even if it produces some kind of smile, chances are the expression will look rather fake. The best way to get a smile on your *subject's* face is to have a smile on *your* face. Making some light conversation and genuinely complimenting your subject will also promote a natural, pleasant smile.

21. THE NECK

The neck really isn't posed, but there are a few points that should be shared about this area.

■ HIDE THE NECK

The neck is the first to show weight gain and age. In many people, as you turn the face, little cord-like tendons pop out, making the subject look like Jim Carrey doing his Fire Marshall Bob routine on *In Living Color* (if you don't happen to be familiar with the character, then trust me—it's not an appealing or flattering look).

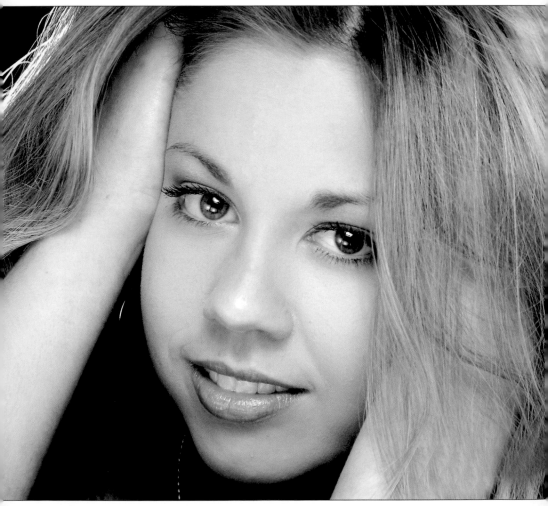

In some poses, the neck is naturally concealed.

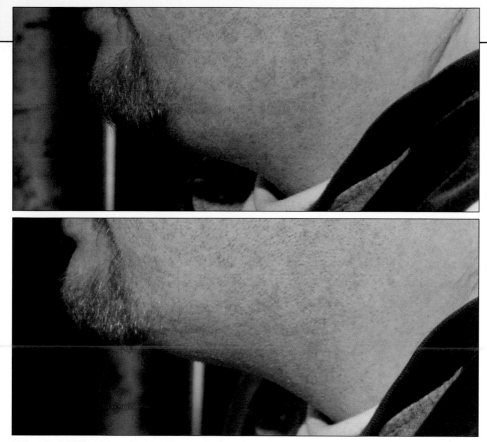

When the subject has a double chin (top), using a "turkey neck" pose (bottom) will make it much less prominent.

The best way to handle the neck area is to cover it up with clothing. If this isn't possible, use a pose that obscures this area from view. Poses like the one on the facing page work well for this.

■ STRETCH THE NECK

If it isn't possible to either conceal or obscure a problematic neck area, then you just have to deal with it.

If the tendons begin to show, have the subject turn their face back toward the camera.

If loose skin or weight gain make this area a problem, have the subject extend their chin out to the camera and then lower their face, basically bowing their neck (which is why this pose is commonly referred to as the "turkey neck"). This will stretch out the skin under the chin and reduce the appearance of a double chin.

22. THE SHOULDERS

Your subject's shoulders should form the compositional base for every head-and-shoulders portrait you take. As mentioned previously, this base (the line of the shoulders) shouldn't form a horizontal line through the frame. A diagonal line makes the portrait more interesting and the subject look less rigid.

■ MEN AND WOMEN

The shoulders of a man should appear broad and at less of an angle than the shoulders of a woman. Women's shoulders can be a very appealing part of a portrait if posed properly. I like when my wife wears dresses that show off her shoulders. However, my wife is thin and very fit. It is always a good idea to have the shoulders covered with clothing if the subject's weight is at all an issue.

■ CLOTHING PROBLEMS

Clothing itself, however, can create problems in this area of the body. Large shoulder pads in a jacket, for example, will make just about any kind of posing impossible, making your subject look like a football player. As you can imagine, this is good for skinny guys but not so good for larger guys or any woman.

In portraits of men, the shoulders should look strong and broad (right). In portraits of women, the shoulders can be at a greater angle for a more dynamic look (facing page).

48

23. THE ARMS: THE BASICS

■ DON'T LET THEM HANG THERE
Arms shouldn't just hang straight down from the shoulders—they should be bent to create diagonal lines that will make the subject look more engaging.

■ SEPARATE FROM THE TORSO
Everyone wants to look as thin as possible in their pictures. By posing your subjects with some space between their arms and their torso, you can make their waist look slimmer.

■ WEAR LONG SLEEVES
Models may have perfect arms, but most people are plagued with a variety of problems—arms that are too large or too boney, loose skin, hair appearing in embarrassing places, stretch marks, bruises, veins, etc. These problems can only be hidden by clothing.

■ DON'T REST WEIGHT ON THEM
Any time weight is put onto the arms (by resting them on the back of a chair, the knee, etc.) it should be placed on the bone of the elbow. If weight is put on the forearm or biceps area, it will cause the area to mushroom and make it appear much larger than it actually is.

24. THE ARMS: VARIATIONS

To learn how to pose the arms, watch people as they are relaxing. They fold their arms, they lean back and relax on one elbow, they lay on their stomachs and relax on both elbows, or they will use their arms to rest their chin and head.

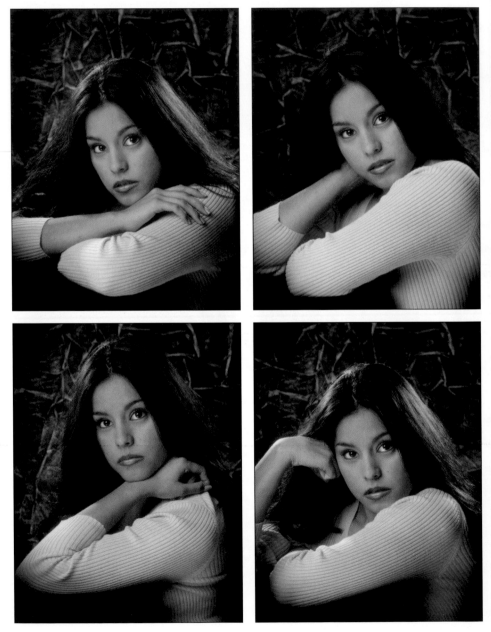

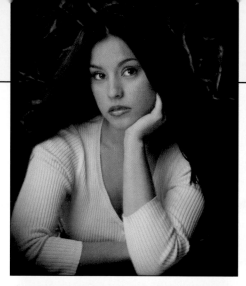
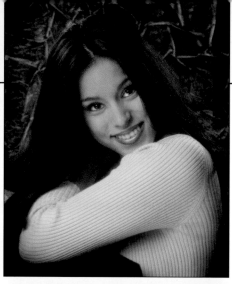
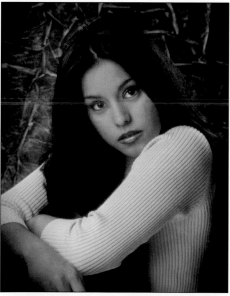
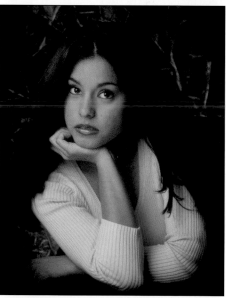
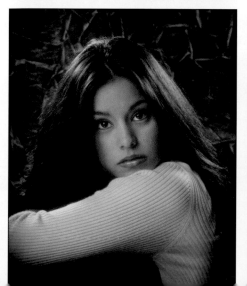
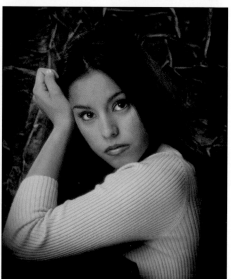

25. THE ARMS: TO CONCEAL PROBLEMS

Posing the arms carefully also gives you the ability to hide problem areas, such as the neck, waistline, or hips. My approach is to pose the subject and then look at them carefully to see if there are any areas that, if I were them, I wouldn't want to see.

If there is a double chin, I lower the chin onto the arms to hide it. If I see a not-so-flat stomach, I may extend the arms out to have the hands around the knees.

Although the young lady in the images on the facing page is quite slim, the snug waistband on her skirt created an unflattering roll (top photo). Moving her arm across her waist (bottom photo) was a simple way to correct the problem. Notice that there is still a small space between her left arm and her torso, so her waist remains well defined.

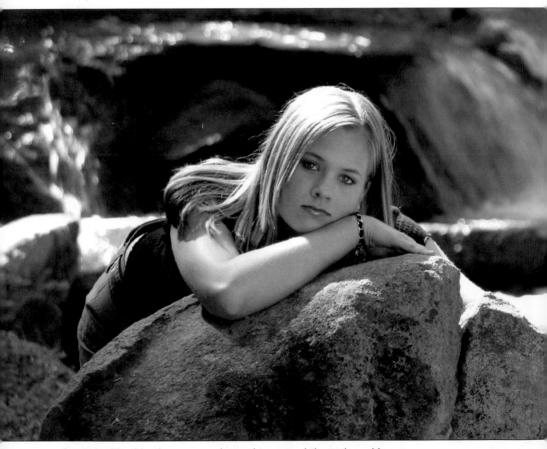

In a pose like this, the arms can be used to conceal the neck or chin area.

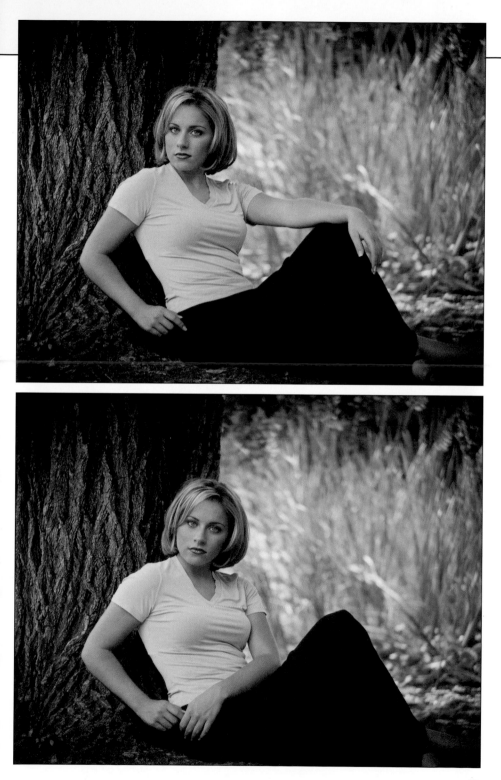

26. THE HANDS

The hands are one of the most difficult areas of the human body to pose effectively. In fact, many photographers simply stick the hands into the pockets—out of sight, out of mind. Here are some better ideas.

■ DON'T LET THEM DANGLE

Hands photograph *worst* when they are left dangling. If you watch people relaxing, in fact, you'll see that they tend to fold their hands or rest them on their body—instinctively avoiding the uncomfortable and unflattering "dangling" positions. Hands also shouldn't look like they are broken (with the fingers or joints at odd angles) or take on the shape of a cow's udder (with the fingers hanging straight down).

■ HOLDING OR RESTING

Generally, the hands of both men and women photograph *best* when they have something to hold on to or something to rest on.

A good strategy is to begin by placing the body and arms where you want them. Then, find a place for the hands to rest (on the subject's knee, the back of a chair, etc.), or give them something to hold (a book, a pen,

Hands look natural when they have something to hold or grasp.

When guys' hands are posed in a fist, it should be a loose fist, as seen in the image on the left. Hands can also be placed in resting positions, such as on the subject's knee, as seen in the image on the right.

a football, the subject's other hand, etc.). This simplifies the entire hand-posing process, allowing you to achieve quick and flattering results.

People often say they don't quite know what to do with their hands, so giving them some direction will also promote a good expression by putting them more at ease.

■ FISTS

Guys don't always have to have their hands in a fist. If they do, however, it should be a relaxed fist that doesn't look like they are about to join in on a brawl (if the knuckles are white, the fist is too tight). If you see that a male subject tends to make a tight fist, give him something to hold instead.

Women should never have their hand in a complete fist. If a woman is to rest her head on a closed hand, try having her extend her index finger straight along the face. This will cause the rest of the fingers to bend naturally toward the palm, without completely curling into it. Even the pinky won't curl under to touch the palm.

27. THE BUST OR CHEST

In most portraits, the bust-line (or the chest, for male subjects) doesn't really need to be considered. Still, occasions do arise when these areas can become an issue.

■ **PURPOSE OF THE PORTRAIT**
Imagine you are photographing a busty woman in a blouse that shows a lot of cleavage. If she asked you to take a picture for her grandmother or if she wanted a business portrait, you'd probably want to minimize the appearance of this area. If you wanted to create a glamorous portrait of the woman for her husband, you would probably want to make the bustline appear as full and appealing as possible.

Similarly, imagine you are photographing a man who works out and has a muscular chest and washboard stomach. If he wanted to show off his muscles in a portrait for his

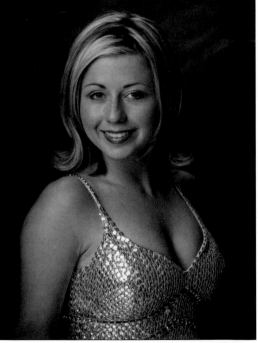

When photographing a woman, you can reduce her apparent bustline by turning her more toward the camera, as in the top image. The area can be further concealed by selecting a shirt that does not reveal cleavage. To enhance the bustline, have the woman turn more to the side (bottom photo) and choosing a cleavage-revealing outfit.

wife, you could have him put on a jacket with no shirt underneath and leave it open. You would also want to use both lighting and posing to bring out the texture of the muscles in this area.

■ ENHANCING

Enhancing the bust or chest really comes down to two factors: controlling highlights and shadows and finessing the position of these body parts with respect to the main source of light.

In the case of the bustline of a woman, size is determined by the appearance of shadow in the cleavage area or the shadow cast under-

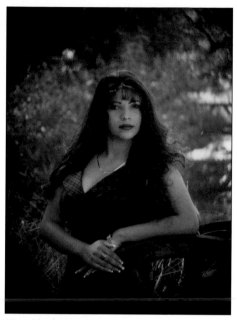

Wearing dark colors, especially black, will help minimize the bustline if it is an area of concern to the subject.

neath the bustline. To increase the shadow in the cleavage area, you simply turn the subject slightly away from the main light source until you achieve the desired effect.

The same lighting procedure can be used in the case of the man who wants to show off his muscular chest (and chiseled abs). By turning the body just enough toward the shadow side of the frame, you will create shadows in each recessed area. The larger the shadows, the larger the muscles look.

■ CONCEALING

If the appearance of a large bustline would be completely inappropriate for the type of portrait being taken, dark clothing will help reduce its apparent size. With black especially, the distinct contours that shape the bust don't show, making it seem smaller and flatter.

You can also reduce or eliminate the shadows in the area. This can be done by simply turning the body of the subject toward the main light source.

28. THE WAISTLINE

■ SEATED SUBJECTS

A common problem with the waistline occurs when the subject is seated and the folds of skin (or stomach) go over the belt. Even the most fit, athletic person you know will have a roll if you have them sit down in a tight pair of pants. There are two ways to fix this problem. First, have the subject straighten their back almost to the point of arching it. This will stretch the area and flatten it out. The second solution is to have the subject put on a looser pair of pants.

■ AT AN ANGLE TO THE CAMERA (USUALLY)

As we have discussed, the widest view of the waistline is when the body is squared off to the camera. The narrowest view of the waist is achieved when the body is turned to the side. The more you turn the waist to the side, the thinner it appears—unless the subject has a round belly.

Imagine that you are photographing a man who is—well, we won't say he's overweight, but he's eight to twelve inches too short for his current weight. If you show his round stomach from the side, you'll make him look like he's nine months along and expecting twins.

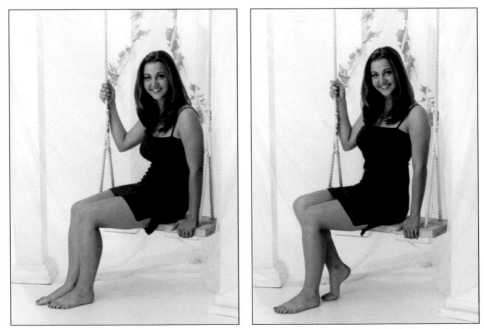

In a slouching pose, the waist doesn't look good (left). Straightening the back looks better (right).

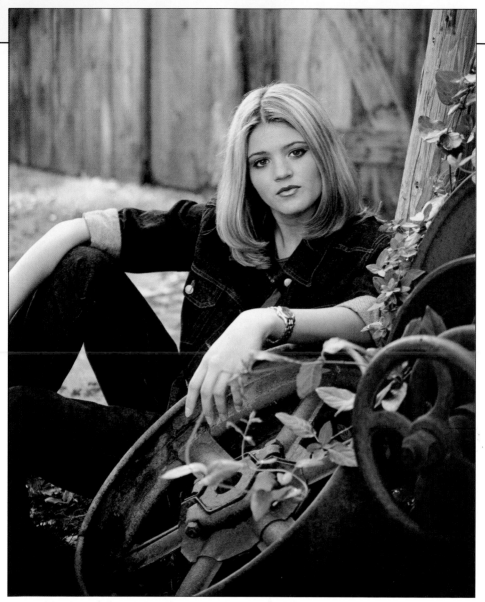

A pose like this can be used to conceal the subject's waistline.

In this case, the prudent thing to do would be to hide his stomach completely. You could do this by hiding it behind something (his arms, another person in a group portrait, etc.). You could also turn his stomach more toward the camera so that its shape isn't so well defined. Finally, you could have him wear dark-colored clothing. If you pair dark clothing with a dark background, you'll get even better results, since the shape of his belly will be very hard to see.

29. THE HIPS AND THIGHS, PART 1

■ **STANDING POSES**

When creating full length images with standing poses, the first basic rule is never to square off the hips to the camera. This is obviously the widest view. In standing poses, rotate the hips to show a side view, turning them toward the shadow side of the frame if weight is at all an issue.

In standing poses, photographers often shift the weight of the hip to accent the hip closest to the camera. This works with a very thin or very curvy woman, but it enlarges the bottom and thigh, which won't make most women very happy.

The legs should never be posed right next to each other in standing poses. There should always be some separation. This can be done by turning the body away from the main source of light and having the subject put one foot up on a step or prop. Alternately, you can have the subject turn at an angle to the lens, put all their weight on the leg closest to the camera, and then cross the other leg over, pointing their toe toward the ground and bringing the heel of the foot up. This type of pose is effective for both men and women.

Clothing also plays an important role in the appearance of the hips and thighs. The baggy clothing that has been popular for the past few years and dress slacks (for both men and women) that are much less than form fitting can sometimes make the thighs appear to be connected.

OUR CHANGING BODIES

As a society, we have become larger people. Fast food and little time to exercise have lead to a nation of overweight people. At the same time, our standard for beauty has become smaller. In the 1950s and '60s, women were "allowed" to have thick hips and thighs, but the current standard of beauty says that women should have the same body frame that most girls have when they are twelve to fifteen years old. Men aren't much better off. The standard has been raised, suggesting that every man should look like a model who has nothing better to do than work on his washboard stomach and tan. No photographer can make an overweight father or mother look like a swimsuit model, but if you understand your subject's feelings and the basics of effective posing, you can create something your subject's ego can live with.

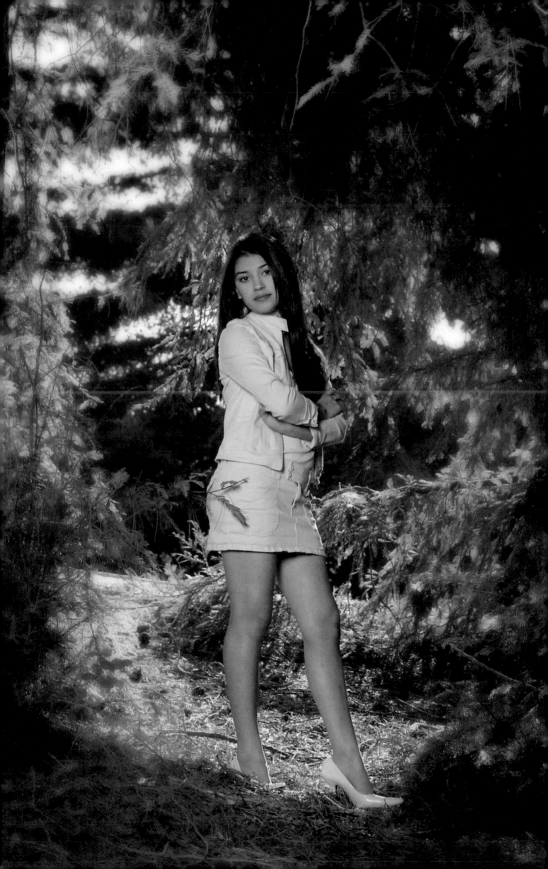

30. THE HIPS AND THIGHS, PART 2

■ SEATED POSES

More can be done to hide or minimize the hips and thighs in a seated rather than a standing pose, but there are still precautions to be taken.

If you sit a person down flat on their bottom, their rear end will mushroom out and make their hips and thighs look even larger. If, on the other hand, you have them roll over onto the hip that is closest to the camera, their bottom will be behind them and most of one thigh and hip will be hidden.

As with standing poses, the legs must be separated, if possible. Obviously, if the subject is a woman who is wearing a short dress, this isn't possible. Instead, simply have her move her lower leg back and bring her upper leg over the top of the lower one. If pants are worn in this same pose, the back foot can be positioned over the front leg and the foot brought back toward the body, causing the knee to raise and achieving a separation between the legs.

When you separate the legs, in this or any other pose, you need to make sure that the area between the legs (the crotch area) isn't unsightly. You may find this problem occurring when the subject is wearing baggy jeans. It also occurs when you have a guy seated with his legs apart, then have him lean forward and rest his arms on his knees. The pose works well because this is the way guys sit, but it puts the crotch area directly at the camera. In this situation, you can use the camera angle and the arms to hide the problem area.

Seated poses like the one above work well for guys—just make sure to use the arms to conceal the crotch area. A pose like the one on the facing page can help to conceal the hips and thighs—as well as the waist.

64

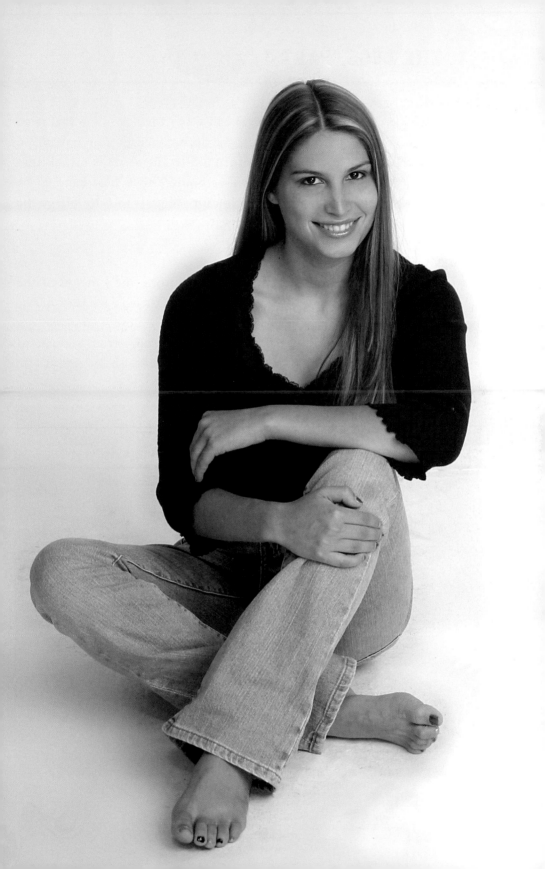

31. THE LEGS, PART 1

■ ANKLES

The ankles are not a problem for most guys, but they can be a real issue for many women. The "cankle" (or the appearance of not having an ankle, but the calf of the leg just connecting to the foot) is a look that many women have and most could live without. This is best handled by suggesting the subject wear pants, looking for tall grass to camouflage the area, or taking the photographs from the waist up.

■ MUSCLE TONE

Legs appear toned when the muscles that run along the outside of the thigh and calf are flexed and visible. (If the subject's legs are very heavy, however, the muscles won't be visible even when flexed, and the leg won't look toned.) These muscles usually become more readily apparent when the heels are raised, as they are with high heels. In bare feet, you can get the same look by posing the feet with the heels elevated.

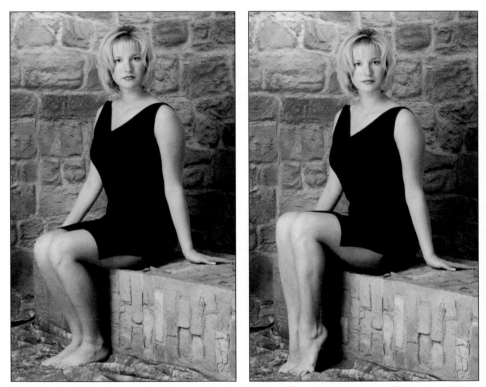

With the heels flat, the legs don't look their best (left). Lifting the heels is more flattering (right).

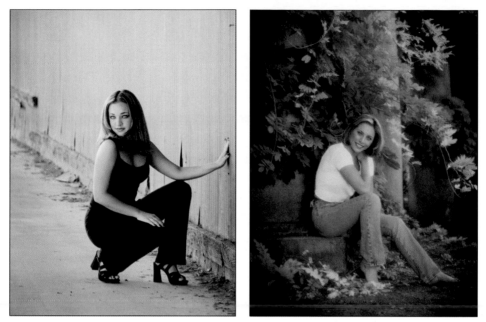

Women's legs look best in high heels or with the heels lifted.

■ COLOR AND NYLONS

If the legs show at all, they should appear to have color—porcelain skin doesn't work on legs. If the subject's legs are very pale, suggest that she bring nylons. Darker nylons tend to look more elegant, while the flesh-toned ones look more "everyday." Nylons should never, however, be worn with open-toed shoes, and reinforced toes should never be visible. Showing nylons with a reinforced toe is right up there with seeing grandma's knee-highs falling down below the hem of her housedress!

■ LEG LENGTH

While you can hide large thighs, making legs look longer isn't easy. If you have the expertise, you can use your digital-imaging software to lengthen them digitally. Alternately, you can use a wide-angle lens and pose the subject with their legs toward the camera. The problem with using a wide-angle lens is that, while you will make the legs look longer, you will also make the subject's feet look absolutely enormous. You might want to save this technique for a friend with really, really small feet!

32. THE LEGS, PART 2

■ PICK AN "ACCENT LEG"

The first bit of advice I give to our young photographers about posing the legs is to pick what I call an "accent leg." Usually, the accent leg is determined by the pose and the orientation of the body. This works in both standing, seated, and laying poses, leaving the other leg as the support or weight-bearing leg. If you use this strategy, you will have cut your work in half since you'll only need to pose one leg instead of two.

Take the classic "James Bond" pose. In this stance, the weight is put on one leg, and the accent leg is crossed over with the toe of the shoe pointing down. Similarly, if you have a woman standing on both feet, you should make one leg the support leg and the other the accent leg. If you have the accent leg angled to the side (rather than the toes pointing at the camera), it will make the pose look even more interesting and flatter the legs even more.

Even in a seated pose, one leg normally extends to the floor in order to, for lack of a better word, "ground" the pose. The body needs to be grounded. Have you ever seen a person with short legs sit in a chair where their feet don't touch the ground? While this is cute for little kids, a pose that is not grounded looks odd for an adult. If you have someone whose feet don't touch the ground, have them sit on the edge of the chair so at least one foot touches the ground, or have both feet brought up into the chair. This grounds the pose by using the chair as the base.

In a seated pose where one leg is grounded, the other leg becomes the accent leg. The accent leg can be "accented" by crossing it over the other, bending it to raise the knee, or folding it over the back of the head (just kidding)—but you need to do something with it to give the pose some style and finish off the composition.

NO POSE WORKS FOR EVERYONE

There is no one pose that will always work. Because of how flexible people are (or are not), as well as how their bodies are designed, no single pose—no matter how simple it is—will make everyone look good. Here, then, is the golden rule of posing: when your subject appears to be having a problem with a pose, scrap it. Don't struggle for five minutes trying to get it to work.

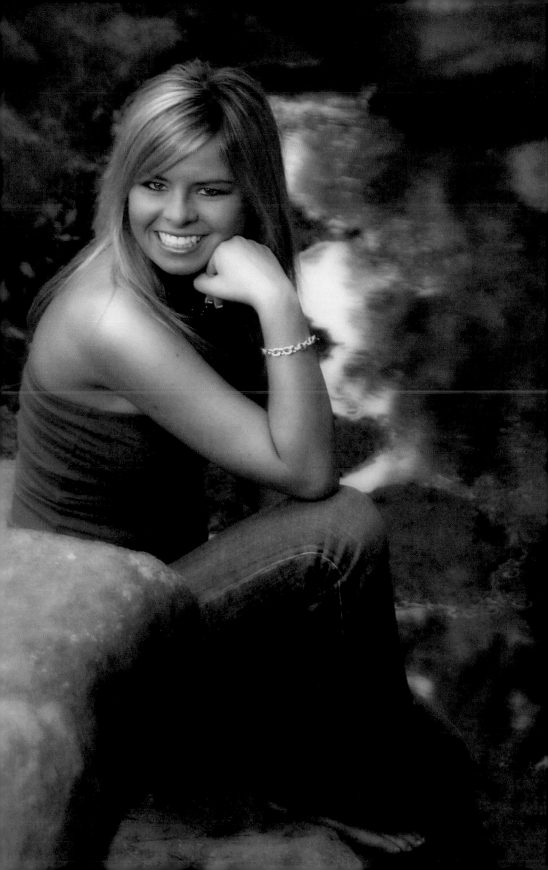

33. THE LEGS, PART 3

There are literally hundreds of ways to make the legs (covered in pants or showing in a dress) look good. The way you choose will depend on your subject and the kind of image you want to create. Use your imagination, and don't be afraid to try unusual poses.

In the box below you'll find a list of the main points to keep in mind when posing your subject. If you follow these guidelines, the pose you create will probably be a flattering one.

TIPS FOR GOOD LEG POSING

1. In a standing pose, never put both feet flat on the ground in a symmetrical perspective to the body.
2. Never position the feet so close together that there is no visible separation between the legs/thighs.
3. Never do the same thing with each leg (with a few exceptions, like when both knees are raised side by side).
4. Never have both feet dangling; one must be grounded.
5. Never bring the accent leg so high that it touches the abdomen.

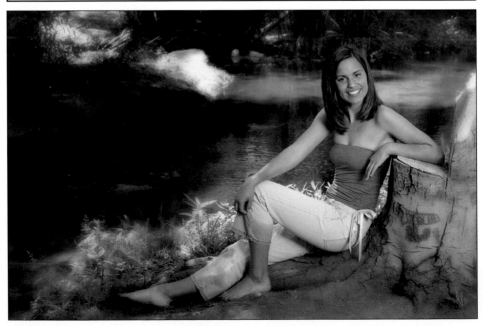

Whether reclining (above) or standing (facing page), the subject's legs should be separated.

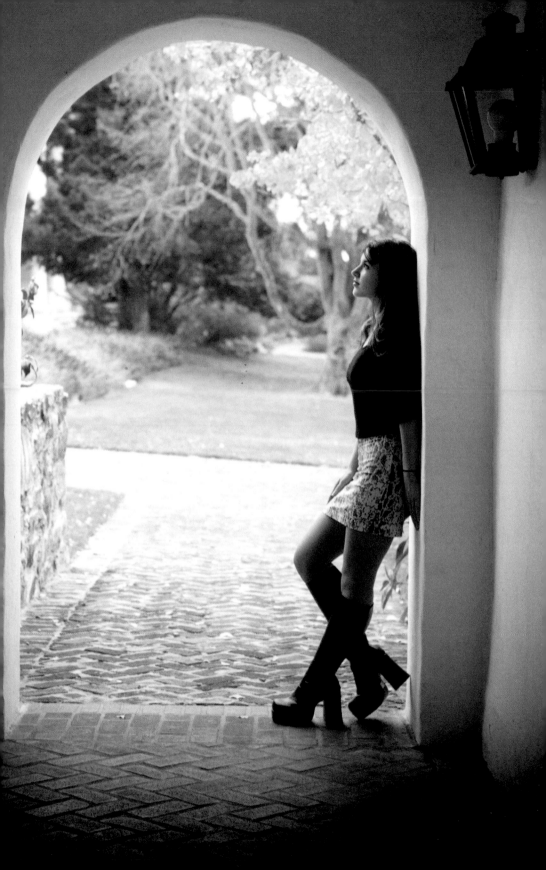

34. THE FEET

Other than the hips, there is no one part of the body as hated as the feet. While casual poses typically look good with bare feet, many people despise the appearance of their feet. I never knew how much the feet were loathed until, eight or nine years ago, we started photographing our senior-portrait clients with bare feet. I would tell each senior who was taking more relaxed poses to kick off their shoes and socks—and I would see a look of horror come over the senior's face. The client would usually explain they hated their feet. Based on their reaction, I expected to see feet with seven toes.

■ BARE FEET

People don't want their feet to appear large or their toes to look long. Also to be avoided are funky colors of toenail polish, long toenails (especially on the guys), or (if possible) poses where the bottom of the feet show. If the bottom of the feet are to show, make sure they are clean.

■ MINIMIZING THE APPARENT SIZE

Bare feet can be made to look smaller by pushing up the heels of the foot. This not only makes the feet look better but also flexes the muscles in the calves, making them look more shapely. If the feet are showing with open-style shoes, the higher the heel, the smaller the foot appears.

■ POSING THE TOES

A subject's tension becomes visible in their toes. If a person is nervous, their toes will either stick up or curl under. Neither one is exactly attractive. Just like the fingers, toes photograph better when they are resting on a surface.

■ SHOES

The subject's footwear should reflect the feeling of his or her outfit. If the subject is in an elegant dress, then high heels should be worn. If the subject is in a business suit, shoes should be worn that reflect the professional look of the clothing. As the clothing gets more casual, tennis shoes or bare feet are the best choices. Wearing socks without shoes really isn't a good idea.

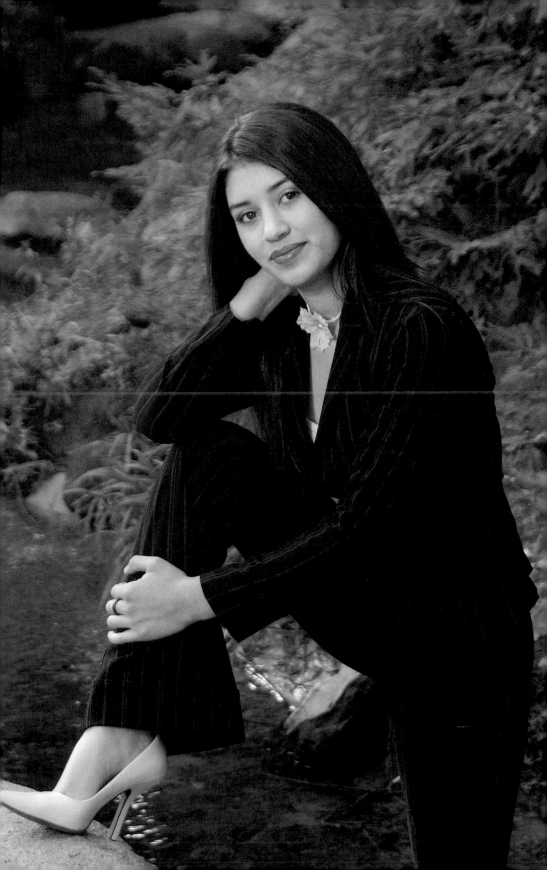

35. CORRECTIVE POSING: WEIGHT, PART 1

To pose the human body effectively, you have to look for ways to cheat. Cheating isn't always a bad thing—especially in photography. In the previous chapters, we looked at some of the ways photographers can make imperfect bodies look their best. This is such an important topic (after all, *everyone* wants to look as good as possible in their portraits) that it bears a more detailed review.

■ OUT OF SIGHT, OUT OF MIND

Most of the people we photograph don't have model-thin bodies. Still, we can make our subjects look thinner by hiding at least part of their body. As they say, out of sight, out of mind.

We've already discussed the fact that you can use an arm, leg, or other part of the subject's body to hide or disguise the area. However, there are lots of other things you can also use. For example, a well-placed pillow, plant, column, or tall grass can help you to achieve a much more flattering portrait of your subject. These conceal the outline of the subject's body and, if weight is at all an issue, create a slimmer line.

Outdoor photography in particular offers so many options for correcting figure problems in this way—but many photographers don't take

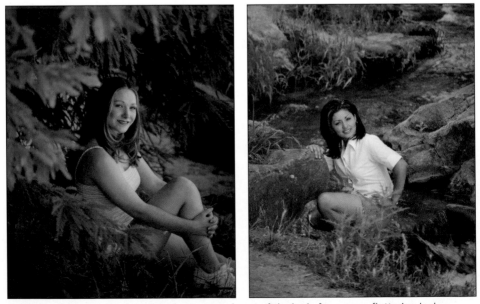

Outdoors, foliage in the foreground can conceal part of the body for a more flattering look.

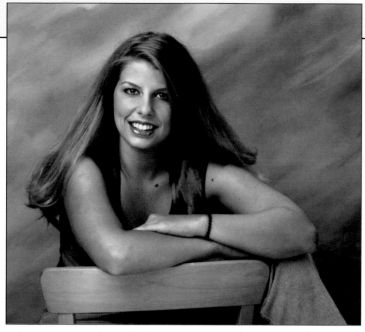

Indoors, a chair back can block your view of the subject's full body.

advantage of them! Most photographers think in terms of the subject and the background, simply placing the subject in a clearing with the selected background behind them. If, however, you place your subject in the *middle* of the scene, you can use foreground elements to conceal part of his or her body. An additional benefit is that doing so will create more of a three-dimensional look in your portrait. This is because you will have a foreground that leads to the subject and then a background that recedes farther and farther from the subject.

The ready availability of these foreground scene elements is one of the reasons I enjoy working outdoors. Something as simple as a tree trunk, bush, or grass in the foreground can hide any affliction, from large hips or stomachs, to white socks or even funky-colored toenail polish.

When you start looking for areas like this in which to pose your subject, you not only create portraits that have much more dimension but also allow you to make your subject look their very best.

When you get into posing multiple people (as we will shortly), you can also use human obstructions, employing one person to hide the shortcomings of another. If Dad has a large stomach, place Mom or one of the kids in front of this area to hide it. If the whole family is larger, you will find that no one wants to be in front. In this case, look for foreground elements to hide what you know the subjects won't want to see.

36. CORRECTIVE POSING: WEIGHT, PART 2

■ AVOID FULL-LENGTH POSES

For any subject with whom weight is a serious issue, you should guide them away from poses that show the hips and thighs. Notice I said "guide." Believe it or not, I've actually heard people say things like, "Well, with hips like yours . . ." or "You are a little hippy, so we probably shouldn't show them in the photograph." A better way to suggest that you not do full-length poses is to make a generalization like, "A lot of women worry about their hips and thighs appearing heavy, so usually it is best to take the poses from the waist up. Is that okay with you?" If you make this gentle suggestion, any woman who worries at all about her

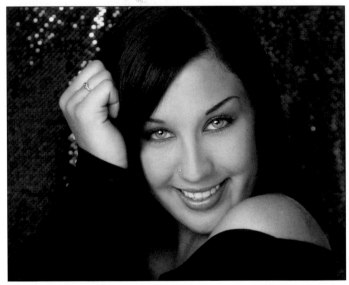

Head-and-shoulder poses can be quite dramatic and have the added benefit of working with every type of figure.

SHOW POSES AND SUGGEST BENEFITS

When creating a portrait, I position myself to show the subject the poses I want them to do. If I know a particular pose would be best suited for the subject, I do the same thing, but when I get to the pose that will slim their hips, I simply say, "Most women worry about their hips and thighs looking as thin as possible. In posing this way, the hips and thighs look thinner. Now, which pose would you like to do?" Without exception, the slimming pose is the one that every woman will select—unless the subject is very thin.

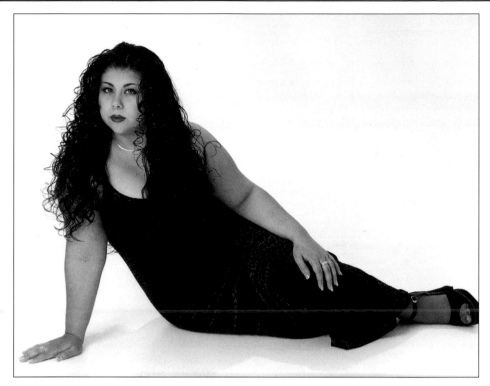

In a seated pose (above) figure problems are more easily concealed than in a standing pose (right).

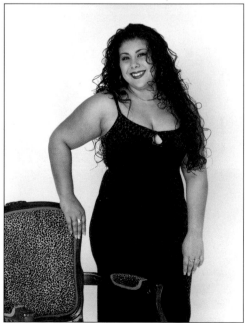

weight will automatically choose to take everything from the waist up.

■ IF YOU MUST DO FULL LENGTH POSES . . .

Sometimes the subject really wants or needs a full length image. In this case, you will do best to choose a seated pose. As was previously noted, this type of pose provides the most options for concealing problems and producing a flattering portrait.

37. CORRECTIVE POSING: EARS, NOSES

■ EARS

Many people are self-conscious about their ears—especially if they are on the large side or tend to stick out.

Long hair can be used to hide the subject's ears.

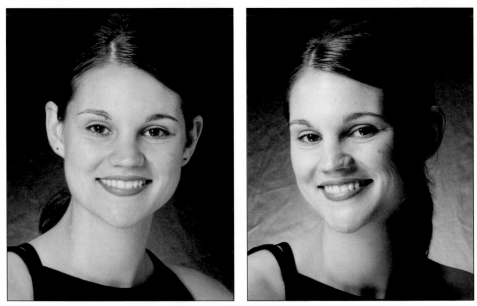

Turning the face toward the main light source until the far ear disappears also helps.

If the subject has prominent ears and long hair, you can use the hair to cover the ears. Make sure that the subject's hair isn't tucked behind her ears, as this will make them stand out. Larger ears can also stick out through the hair making them appear *really* large, so look out for this.

The best way to reduce the prominence of the ears is to turn the face toward the main light source to a point where the far ear is obscured from the camera's view. This will reduce the effect of the ear "sticking out," especially since the visible ear will be in lower light than the rest of the face.

■ NOSES

The nose is only seen in a portrait because of the shadows that are around it. By turning the subject's face more toward the light you can reduce the shadow on the side of the nose, and thereby reduce the apparent size of the nose.

The highlight that runs down the nose on shiny skin also draws attention to the size of the nose. This can be a problem with a subject who has oily skin or when you are shooting outdoors and warm weather causes the subject to perspire. Translucent powder will eliminate this shine.

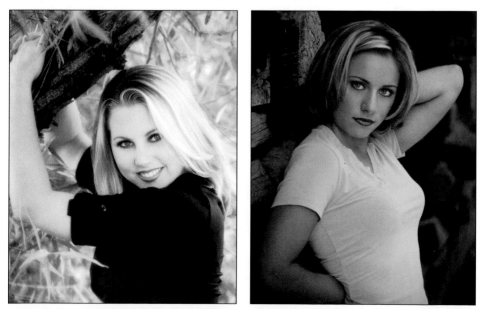

Light shadows (left) minimize the look of the nose; deeper ones (right) make it more prominent.

38. CORRECTIVE POSING: GLASSES

Unless your subject has nonreflective lenses, glare on their glasses is almost always going to be a problem. The best solution is to have your subject remove them, but many eyeglass-wearers aren't at all comfortable with this. Professional photographers face the same problem, so they ask their clients to get empty frames (frames without lenses) from their eye doctors.

Another technique used to reduce the glare is to raise the earpieces of the glasses so that the lenses point slightly downward. This is usually enough to reduce the glare, and the change of angle on the glasses isn't

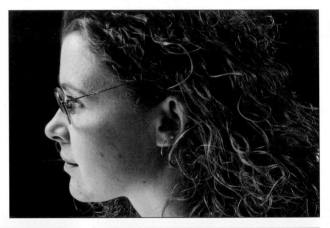

Glare on glasses is a problem in many portraits (bottom left). Tilting the earpieces of the glasses up slightly (right) can fix the problem (bottom right) and the tilt won't be visible from the camera position.

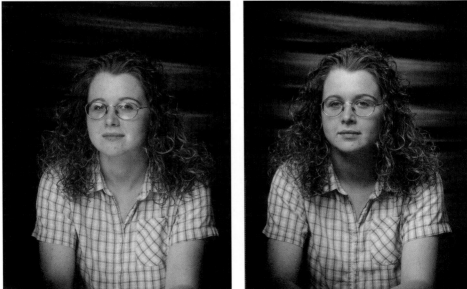

PORTRAITS WITH EMOTION AND LASTING VALUE

Emotion. Posing a portrait effectively requires you to have an ability to convey emotions. This is one of the reasons why many photographers have a hard time with posing. They understand the *technical* side of photography but think it is unnecessary to understand the *emotional* aspects. I had a photographer at my studio a few years back who was very skilled with the nuts and bolts of photography; he made no secret of the fact he wanted to open his own studio before long. I used to tell him that he knew more than enough about photography to succeed but that he needed to study life. He didn't understand what I meant by that. I told him that you can't create feeling in a portrait without being able to possess that feeling yourself. Successful photographers *feel* much more than they *know!*

Lasting Appeal. Many photographers take a portrait and get excited. They are impressed with their work of art and order a big print. When they get the print back, they are still excited, but not as excited as when they first saw the shot. After about a month, their excitement has passed and all they can see are the mistakes they made. Portrait subjects go through this, too. They get excited right after the images are created . . . but often their enthusiasm fades over time. If, however, the photographer has done his or her job and created a portrait that has a sense of style and evokes the desired emotional response, the portrait will have lasting appeal, even if the clothes and hairstyles become dated. When you look at your subject with compassion, when you understand the areas of the body that we all worry about, when you judge the appearance of the person in front of your camera with the same "rose-colored glasses" that you (and everyone else) use when you look at yourself in the mirror, then and only then will you create portraits with lasting appeal.

noticeable from the perspective of the camera. This isn't an ideal solution, but it is manageable.

You can also use a light source that hits the subject's face from a very high angle (like a skylight, late-morning sun, etc.). Because of the position of the light, you may find that no glare is visible from the perspective of the camera. The problem with this strategy, however, is that it probably won't make your subject look her best.

39. PROPS FOR POSING

It can be very difficult to figure out a pose for your subject when he or she is just standing there in an empty space. Therefore, you should consider using chairs, steps, doorways, and any other props that provide an easy way to at least begin the posing. The images here show a few uses of such props—but these are just a starting point. Take a walk around your house and yard to see what other "portrait-perfect" props and portrait locations you have at hand.

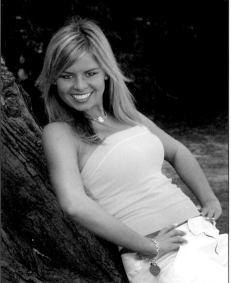

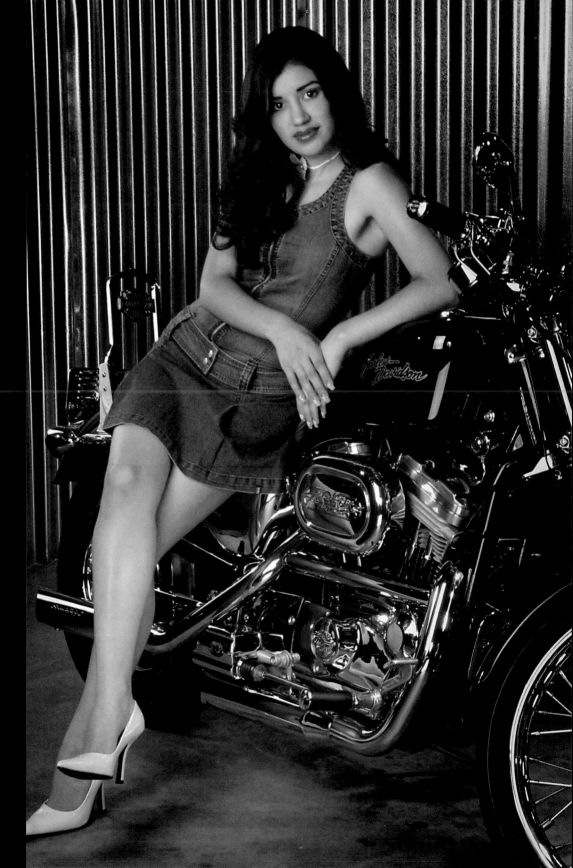

40. COMPOSITION BASICS

Composition is the technique used to arrange the elements of your image so that they draw the viewer's eyes to the main subject. In portraits, this is almost always the subject's eyes. The rule of thirds is a good compositional guideline to use as you are learning to pose portraits. According to this rule, the image is divided up like a tic-tac-toe board (see diagram to the right). Your subject's eyes can be successfully placed along any of these lines and are further emphasized by placing them at the intersection of any two lines (these intersections are often called "power points"). Whether your image is horizontal or vertical, the rule of thirds applies in exactly the same way.

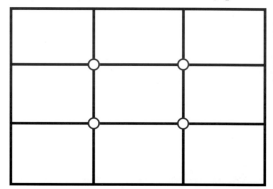

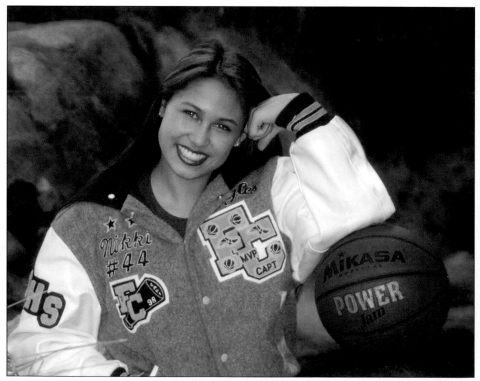

In most portraits, the subject's eyes should be about one third of the way from the top of the frame.

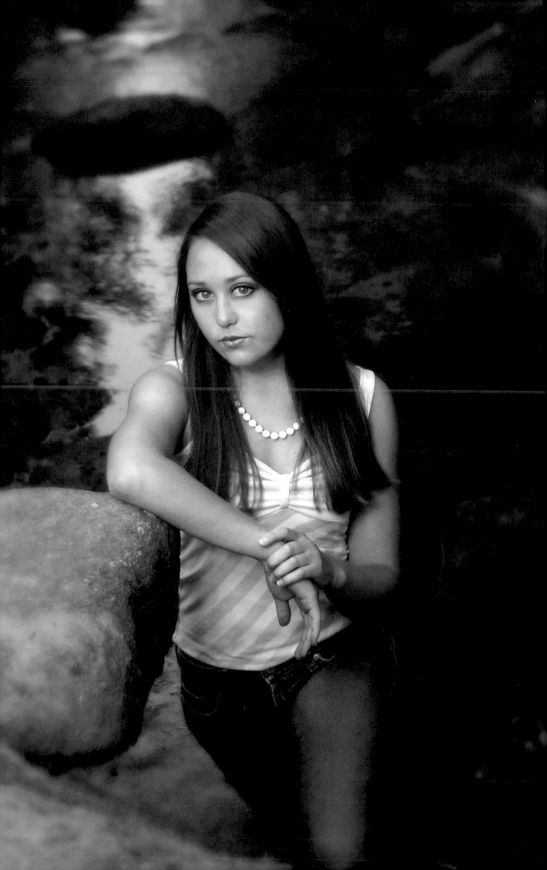

41. FINISHING OFF THE FRAME

The final step in creating a professional-looking portrait is to do what I call "finishing off the frame." This refers to selecting the right area of the subject at which to frame the bottom of the image.

In a head-and-shoulders image, the composition of a portrait looks finished if the shoulders fill the bottom of the frame from one side to the other. If the portrait is composed showing more of the body, then the arms are used to fill in the void areas at the bottom of the frame. Basically, this is completing a triangular composition, with the shoulders and arms forming the base of the triangle and the head at its peak.

Even when you include more of the subject than the typical head-and-shoulders pose, the body should be used to form a triangular composition. This is a helpful concept for many photographers who are starting to learn posing but have a hard time trying to decide where the bottom of the frame should be (waistline? thighs? knees?). Just look for the bottom of the triangle and crop the portrait there.

As you see in most of the photographs in this book, by using the body to fill the base of the composition you can ensure that the portrait appears finished. It looks as though the photographer put some thought into coordinating the pose with the final composition.

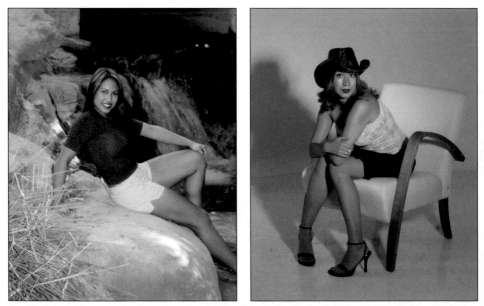

In all three images, notice how the subject's head is at the peak of a triangle created by the body.

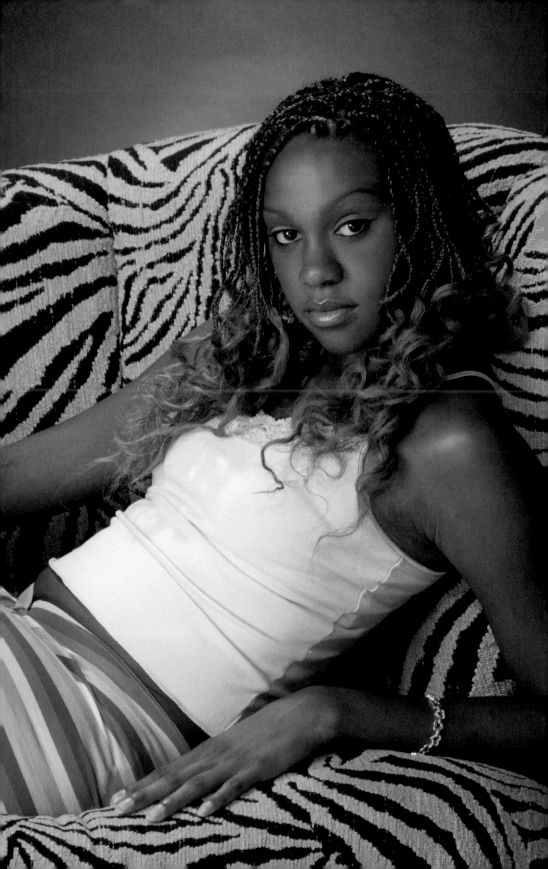

42. SIMPLE VARIATIONS

■ DIFFERENT COMPOSITIONS

Many poses offer a photographer the ability to choose from different ways to compose the portrait. Once the subject is in the pose, you can take a full length, three-quarter length, and head-and-shoulders shot without having the subject move at all.

■ SMALL CHANGES

When you want to create a variety of images with one subject, it's not always necessary to make huge changes in the pose for each shot. Often, just moving the arms, cross-

In many poses, you can create a variety of images without having to move the subject at all. Here, a full length (right), a three-quarter length (bottom left), and a head-and-shoulders image (bottom right) were all created from the same pose.

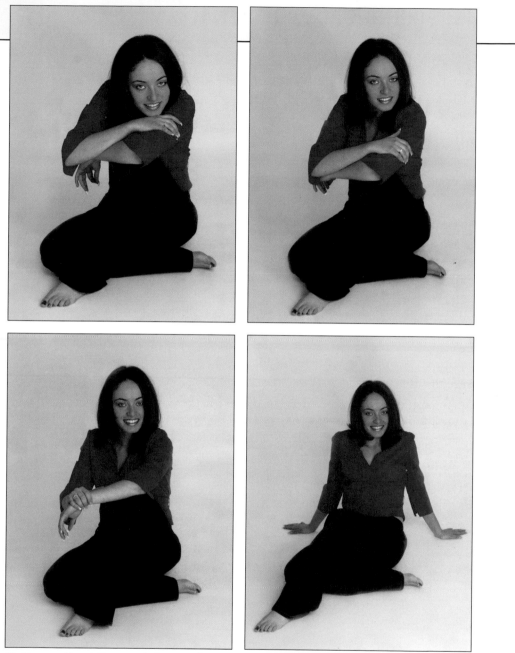

Making small variations can help you refine a pose or create a different look.

ing the legs differently, or using a different angle on the face will produce a look that is totally distinct from the previous pose. Making small adjustments is also a good way to refine a pose and find the look that makes your subject look his or her best.

43. POSING GROUP PORTRAITS

Posing takes on a whole new dimension when it comes to arranging two or more subjects within a single composition. However, all the same rules for posing one person still apply to posing multiple people. There are just a few additional things to keep in mind.

■ PROXIMITY AND COMPOSITION

As you pose the subjects within a group, keep a similar distance between each person. If one person seems to be farther away from the group, they will look like they don't belong. How close should you pose your subjects? There are several factors to consider. First, you might want to choose a close grouping if there is a baby in the photo, lowering the adults down to the baby's level. Tighter groupings are also good for families who want to show their closeness. Closer groupings show only a small amount of the background, so they can also be used when you don't want to show much of the setting. If, on the other hand, you want to show more of the scene or plan to use large props (horses, cars, ATVs, etc.), then the grouping will have to be more spaced out.

■ HEAD PLACEMENT

Avoid placing anyone's head on the same level as another person's head. This can be challenging with larger groups, but it keeps the pose from looking like a police lineup. With fifty people, you might have several people at the same height, but that's just life— and sometimes art must suffer when you need to photograph that big a group. In a photograph of two people, the mouth of the higher subject should be at about the same level as the eyes of the lower subject.

■ START WITH THE CORE

In posing a group, you should start out with the core people. This could be Mom and Dad, Grandpa and Grandma, a baby—it all depends on the portrait. Once the core is in place, you can start posing additional people around that point of focus.

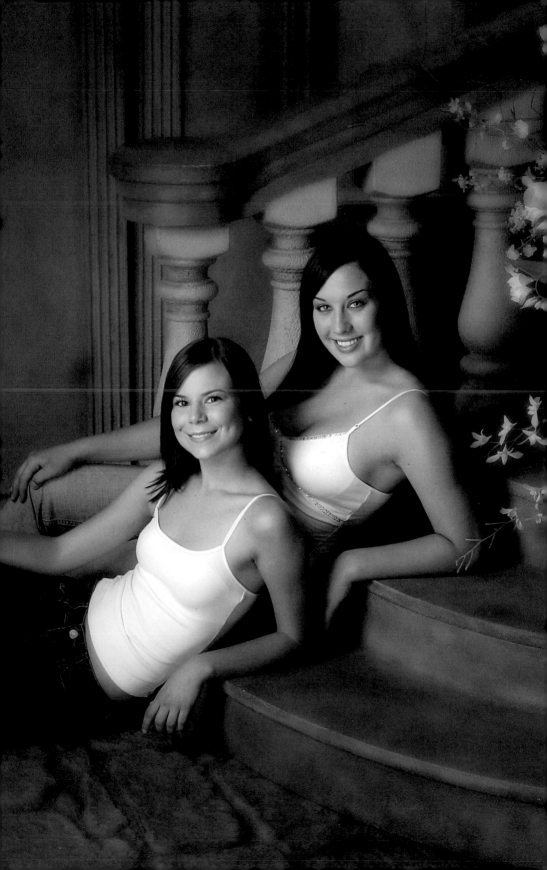

CONCLUSION

Posing that makes your subject look attractive is a goal for all photographers. When posing is also tailored to fit the purpose for which the portrait is to be taken, coordinates with the overall feeling and style you are creating, and makes the client look outstanding, you are creating portraits with lasting appeal.

Remember to give your best to each subject. You won't become the best photographer you can be by making beautiful people look beautiful; you'll become a better photographer when you learn to make *everyone* look good.

Look to learn, look to grow, and remember the words of my father, "As long as a man thinks of himself as green, he is growing; it's only when he considers himself grown that he begins to die." May you always be growing, and good luck on your journeys!

ABOUT THE AUTHOR

Jeff Smith is a professional photographer and the owner of two very successful studios in central California. His numerous articles have appeared in *Rangefinder, Professional Photographer,* and *Studio Photography and Design* magazines. Jeff has been a featured speaker at the Senior Photographers International Convention, as well as at numerous seminars for professional photographers. He has written seven books, including *Outdoor and Location Portrait Photography, Corrective Lighting and Posing Techniques for Portrait Photographers, Professional Digital Portrait Photography,* and *Success in Portrait Photography* (all from Amherst Media®). His common-sense approach to photography makes the information he presents both practical and very easy to understand.

INDEX

BEGINNER'S GUIDE TO PHOTOGRAPHIC LIGHTING

Don Marr

Learn how to create high-impact photographs of any subject (portraits, still lifes, architectural images, and more) with Marr's simple techniques. From edgy and dynamic to subdued and natural, this book will show you how to get the myriad effects you're after—and you won't need a lot of complicated equipment to create professional-looking results! $29.95 list, 8½x11, 128p, 150 color photos, index, order no. 1785.

PROFESSIONAL TECHNIQUES FOR
BLACK & WHITE DIGITAL PHOTOGRAPHY

Patrick Rice

Black & white photography is an enduring favorite among photographers—and digital imaging now makes it easier than ever to create this classic look. From shooting techniques to refining your images in the new digital darkroom, this book is packed with step-by-step techniques (including tips for black & white digital infrared photography) that will help you achieve dazzling results! $29.95 list, 8½x11, 128p, 100 color photos, index, order no. 1798.

THE PRACTICAL GUIDE TO DIGITAL IMAGING

Michelle Perkins

This book takes the mystery (and intimidation!) out of digital imaging. Short, simple lessons make it easy to master all the terms and techniques. Includes: making smart choices when selecting a digital camera; techniques for shooting digital photographs; step-by-step instructions for refining your images; and creative ideas for outputting your digital photos. Techniques are also included for digitizing film images, refining (or restoring) them, and making great prints. $29.95 list, 8½x11, 128p, 150 color images, index, order no. 1799.